THE BRITISH LIBRARY GUIDE TO

Printing

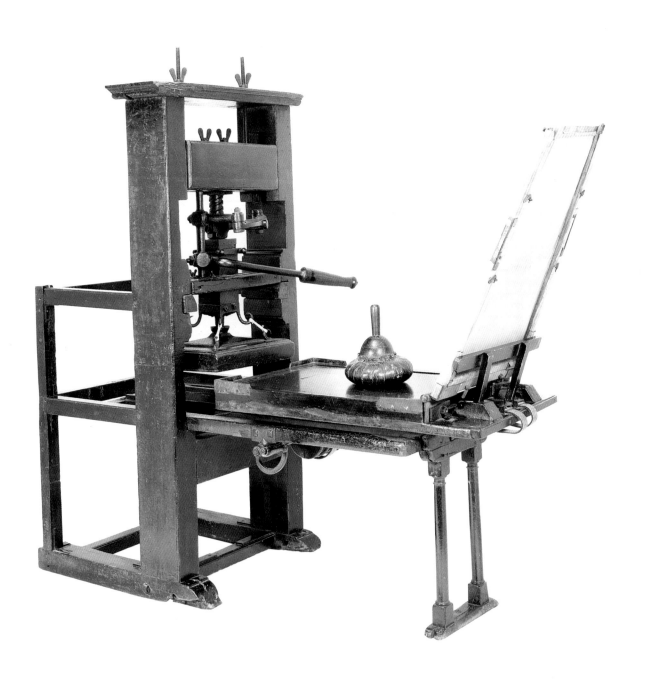

FRONTISPIECE Wooden press for relief printing, known as a common press. This example in the St Bride Printing Library, London, is of a kind made in England in the eighteenth century, but has a lever movement of the early nineteenth century. On the bed of the press is an inking ball.

THE BRITISH LIBRARY GUIDE TO

Printing

HISTORY AND TECHNIQUES

Michael Twyman

UNIVERSITY OF TORONTO PRESS

COVER Printer's mark of Jodocus Badius, Paris, 1520.

TITLE-PAGE Trade card of Nathaniel Pearce, a letterpress, copper-plate, and lithographic printer working in London in the mid nineteenth century.

© 1998 in text, Michael Twyman
© 1998 in illustrations, The British Library Board and other named copyright holders

First published 1998 by
The British Library
96 Euston Road
London NW1 2DB

Published in North and South America in 1999 by
University of Toronto Press Incorporated
Toronto and Buffalo

Canadian Cataloguing in Publication Data

Twyman, Michael
 The British Library Guide to Printing

(The British Library Guides)
Includes bibliographical references and index.
ISBN 0-8020-8179-7

1. Printing - History. I. Title. II. Series.
Z124.T89 1998 686.2'09 C98-932301-3

Designed by Andrew Shoolbred
Origination by Culver Graphics
Printed in Italy by Grafiche Milani, Milan

Contents

Acknowledgements

It would be impossible to thank all those from whom I have learned about printing over the years, though I am conscious that I must have drawn heavily on their work when writing this book without always realizing it. Some of their names will be found under the heading 'Further reading' on page 83. I am particularly grateful to James Mosley and Lawrence Wallis, who were kind enough to read the whole of my draft text and made several constructive suggestions. In addition, Alan May, Beth McKillop, and Frances Wood made valuable comments about those parts of the text that relate to their specialisms, and Martin Andrews, Iain Bain, Terry Belanger, Michael Gray, Basil Kahan, David Knott, Ian Mumford, Margaret Smith, and Stephen Watson all helped by answering questions or finding appropriate illustrations. For permission to reproduce items I would like to thank:

The Bodleian Library, John Johnson Collection, title-page image; The Book Arts Press, University of Virginia, 49; The British Library, 7,10,11,17,18, 20,22,23,26,27,29,30,31,38,39,56; The British Museum, Department of Prints and Drawings, 1,2,24,25,47; Cambridge University Library, 23,27; Department of Typography & Graphic Communication, The University of Reading, 9,37,44,61,64; Deutsches Museum, Munich, 34; Fox Talbot Museum, 62; Gutenberg Museum, Mainz, 19; John Rylands Library, Manchester, 16; Oxford University Press, 5,15,58; Plantin-Moretus Museum, Antwerp, 14,28; Private Collections, 32,33,36,41,42,45,57,60; Rural History Centre, The University of Reading, 50; St Bride Printing Library, frontispiece,12,40,51,55,63; The University of Reading Library 6,8,13,21,33,35,43,46,48,52,53,54,59; Victoria Art Gallery, Bath, 3.

Introduction

Printing is generally held to be one of the most important inventions of all time and to have helped change the course of history. Yet we are not altogether clear what it is and may therefore respond in different ways when asked when and where it was invented.

This short history is about the techniques of printing. Most other books on the history of printing concentrate on grander issues: its impact on society, major figures involved with it, and the finest or most influential printed artefacts. Histories of this kind are essential since, in the long run, a technology is only as important as its products and their uses. Nevertheless, printing techniques have always played a part in shaping their end product, and in some cases have even provided the impetus for particular developments in the publication of documents. For this reason alone it may be helpful to know how printing was done in the past.

The most obvious starting point for those interested in printing methods are printed artefacts themselves, since they always provide us with some evidence about their production. Evidence of this kind is easier for us to interpret when it is backed up by hands-on experience of printing and by reading contemporary technical accounts. It is also helpful to have some knowledge of the materials and equipment used in the past, such as presses, tools, types, blocks, and plates. On occasions, we might even be lucky enough to discover a description of how a particular piece of printing was produced. Mostly, however, we have to make do with whatever evidence we can find.

What is printing?

Printing can be described as a means of giving form to and multi-plying graphic signs and messages. Before printing was invented such things would have been produced singly by drawing and writing; today, they may well be generated entirely by electronic means. The extraordinary social, artistic, and intellectual impact printing has had derives to a large degree from its technical appropriateness and adaptability. The ideas that lie at the heart of printing have simply been modified over the years in response to major technological shifts from hand to machine and then electronic production.

It may be helpful to define two distinct stages in what we call printing: origination and multiplication. These terms are not sacro-sanct, and in electronic production may not be easily differentiated. Nevertheless, it is important to consider them separately when discussing the history of printing because, at certain points in time, major advances were made in the one and not in the other.

Origination

The word origination is used here to describe the organization and production of the marks to be printed; it applies to marks cut by hand, made photomechanically, and controlled by computers. The word commonly used for this stage of printing today is pre-press. Both terms cover the arrangement of words in linear strings (as in the text pages of books) and when displayed (as in most advertising); they also cover the use of pictorial, decorative, and other non-verbal material.

What is usually referred to as the invention of printing relates to a set of advances made at the origination stage. This was the contrib-

ution of Johann Gutenberg (1390s–1468) in Germany in the mid fifteenth century, and it involved the replication of separate re-usable letters and their arrangement in rows. This was a highly significant step in the advance of printing because it allowed for corrections to be made relatively easily and in a seamless way. It has also strongly influenced our interpretation of the word printing. All the same, there are artefacts that we rightly describe as printed which owe little if anything to Gutenberg's invention in terms of origination. They include numerous books and prints made in the Far East several hundred years earlier, in addition to present-day work as diverse as wrapping paper and reproductions of paintings.

At one end of the origination spectrum of printing lie images that can be made directly by hand: that is, they are cut or otherwise produced on a printing surface, such as wood or metal, by the person who designed them. At the other end lie drawn or written marks that are turned into printable form by someone else (for example, by a compositor using pre-manufactured pieces of metal type, or specialist engravers working manually on a physical surface from someone else's originals). In the nineteenth century certain kinds of work that started life as marks made by an artist or letterer on paper were later transferred, without alteration, to the printing surface; these methods can be seen as falling somewhere near the middle of the origination spectrum.

For centuries, all printing surfaces could be fitted into a binary classification: relief and intaglio. In relief printing the marks to be printed stand higher than the non-printing parts (fig. 1); in intaglio printing the opposite is the case and it is the hollow parts of the surface that produce the printed marks (fig. 2). Printing from metal type and wood blocks fall into the first category; printing from engraved or etched copper plates and the associated tonal processes of mezzotint and aquatint into the second. This simple classification began to be challenged when lithography was invented in Bavaria by Alois Senefelder (1771–1834) in or around 1798. Unlike the two older branches of printing, which depend on physical differences in relief to determine the printing and non-printing areas, lithography rests on chemical principles. Lithographic printing surfaces are to all intents and purposes on the same level, which explains why this third category of printing has come to be described as planographic (fig. 3).

By the beginning of the nineteenth century, therefore, the binary

1. Relief printing from wood. Detail of the woodcut block for Dürer's 'Hercules' (*c.*1496), showing the image to be printed standing in relief. The non-printing areas have been cut away with knives and gouges. Printing would have been done by inking the areas standing in relief, placing paper on the inked-up surface, and applying pressure.

2. Intaglio printing from copper. Detail of the copper plate engraved by Edward Calvert, entitled 'The Bride' (1828), showing the lines to be printed lower than the plate. The lines of the engraving were produced with a pointed steel tool known as a burin, which produced thicker lines the deeper it went into the copper. Printing involved squeezing ink into the engraved hollows, wiping the surface of the plate clean, placing paper on it, and forcing ink out of the lines under considerable pressure.

3. Planographic printing from stone. Detail of a lithographic stone drawn in greasy ink by Thomas Barker for his *Forty lithographic impressions of rustic figures* (Bath, 1813). The drawn marks are on the same level as the surface of the stone and the process works because grease and water do not readily mix. To take a print from the greasy image the stone is damped before printing ink is applied: the non-printing areas attract the water and repel the greasy printing ink; the greasy marks of the drawing attract the printing ink and tend to repel the water.

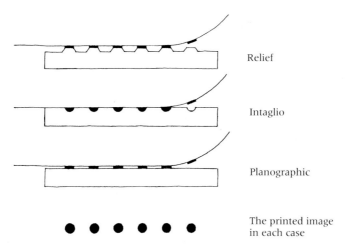

Relief

Intaglio

Planographic

The printed image
in each case

4. Diagram showing the main categories of printing: relief, intaglio, and planographic. In each case a piece of paper is shown being removed from the inked-up printing surface. Nearly all printing surfaces were flat before the middle of the nineteenth century; thereafter they were frequently cylindrical.

classification of printing had turned into a tripartite one: relief, intaglio, and planographic (fig. 4). This remains the orthodox way of classifying printing processes generically, though by the middle of the nineteenth century so many different forms of printing had been tried that it was beginning to become a little shaky. For example, William Stannard, who compiled a compendium of printing processes called *The art exemplar*, which he published in just ten copies around 1859, described and illustrated as many as 156 printing methods, some of which do not fit very neatly into the tripartite model. In recent years too the model has become a little frayed at the edges with the introduction of output devices used in conjunction with computers. Nevertheless, the tripartite model, which was first advanced by the inventor of lithography in the early nineteenth century, still provides a convenient one for considering the origination and multiplication stages of printing in relation to both hand and machine production.

Before the nineteenth century all printing involved the lateral reversal of images. This meant that words and other material designed for printing had to be made the wrong way round: the letters on metal type were produced back to front (fig. 5), and so too were images on wood blocks, intaglio plates, and, later, lithographic stones. This was an inescapable problem until two nineteenth-century developments provided a solution to it at the origination stage: first transfer lithography, and then, from the middle of the century, the application of photography to printing processes. Later the problem was solved at the multiplication stage by offsetting the image on to an intermediate

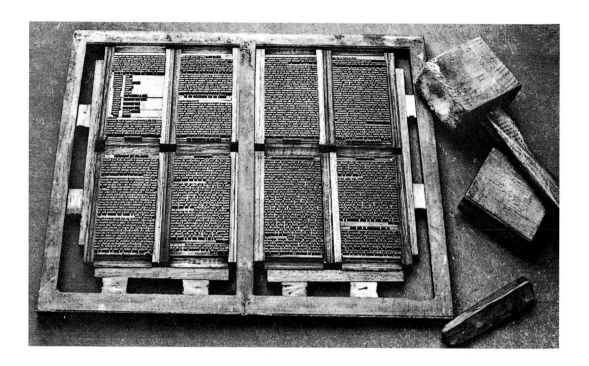

5. A forme of type: that is, type locked up in a metal frame (chase) and ready for printing. The letters are back to front and the lines read from right to left. The pages of type are separated by spacing material made of wood (furniture) and made secure by pairs of wedges (quoins) which apply pressure sideways. To the right are a mallet and planer for levelling the type and a shooting stick, which was used with the mallet to drive the quoins together.

cylinder within the press. In this method of printing the image started life the right way round, was reversed in the press, and appeared the right way round when printed.

Multiplication

The word multiplication is used here to describe the second stage of printing, the production of more or less identical copies of an item in the form of a print run. Confusingly, the word printing is also used to describe this stage alone. This seems to suggest that – in common language at least – we accept the word printing as meaning something rather different from what we credit Gutenberg with having invented in the mid fifteenth century. Moreover, though we have an expectation that printing involves the production of multiple copies, the word can also be used to describe the activity of taking a single copy from a printing surface.

Printing in the sense of multiplication can be done on a wide range of substrates and with different kinds of inks. Cloth, glass, leather, metal, plastic, and wood are among those materials that have been used for printing. But from its beginnings in both the Far East and

12

Europe printing of all kinds found a natural ally in paper (fig. 6). Paper consists primarily of vegetable fibre and is well suited to printing because of its absorbency and flexibility. It was invented in the Far East long before printing was practised and, when made by hand from good-quality material such as rags, has proved extremely durable. What is more, paper can be made in a wide variety of sizes, textures, colours, and finishes. It was originally made in sheets, but from the early nineteenth century, when paper began to be manufactured by machine, it was produced in a continuous length on a reel. Its greatest drawback is that it is hygroscopic, which means that it is sensitive to moisture and therefore dimensionally unstable. Nevertheless, for all its limitations, no better all-purpose alternative has yet been found for printing.

The inks used for printing have also remained remarkably consistent, given the enormous changes printing has undergone over the

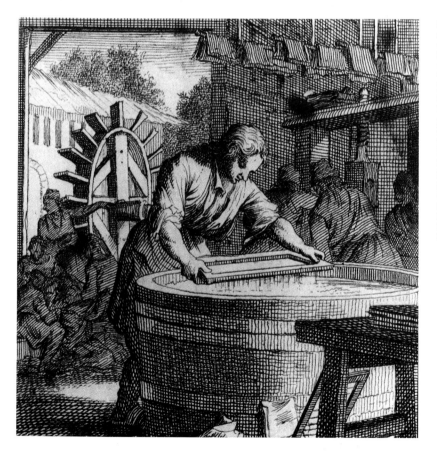

6. Paper making by hand as shown in a Dutch book of trades: Abraham van St Clara, *Iets voor allen* (Amsterdam, 1717, 1719). The paper maker (vatman) is seen lifting a mould from a vat of paper pulp. The resulting sheet of paper would then have been transferred to a pile, each sheet being interleaved with felt. After this the pile was put under pressure in a standing press (shown on the right) to extract as much water as possible. The final stage of drying involved hanging up sheets on lines. Image 87 × 73 mm.

centuries. Though water-based inks have been used in Europe from time to time, and more generally in the Far East, most printing inks consist of pigments mixed in oil; in this respect they are not substantially different from printing ink used in the mid fifteenth century.

The multiplication of prints can be done without any special apparatus if the printing surface is not too large and not very many copies are needed. Some of the earliest printing in the Far East and Europe would have been done by pressing an inked-up relief block against a sheet of paper or piece of cloth, or by placing paper on the inked surface and rubbing it from behind. The last of these methods is occasionally used by artist wood-engravers today. The special apparatus that was developed to make it easier to produce multiple copies of a document in large quantities was the press.

The first printing presses were those devised for relief printing in the mid fifteenth century. From then on, presses came to be regarded as essential at the multiplication stage of printing. In addition to speeding up production, they made it easier to produce more or less uniform prints in a precise position on a sheet of paper. In the course of time, presses were tailor-made for each of the three major branches of printing in order to apply sufficient pressure in an appropriate way and without doing damage to the printing surface.

As more and more copies of items were needed in response to the growth of literacy, trade, and travel, emphasis shifted to speed of output. In the first quarter of the nineteenth century hand-operated printing presses began to be replaced by powered printing machines, and from the 1860s the fastest machines were fed with paper from the reel rather than in the form of sheets. The vastly increased quantities of materials needed as a result of the greater output of printing machines inevitably led to changes in the manufacture of paper, and especially in the materials used in its production.

Words and pictures

Printing is, and always has been, concerned with both words and pictures, and this presents several problems. First, though letters and numbers lend themselves to being arranged in different permutations, the same idea is not easily applied to pictures. Types are commonly designed for a range of applications whereas pictures, though sometimes re-used, are normally made for a single or limited range of

7. (OPPOSITE) Woodcuts were used in most of the earliest illustrated printed books, as here in Hartmann Schedel's, *Weltchronik,* usually called the *Nuremberg Chronicle,* which was printed by Koberger in Nuremberg in 1493. It was very common for some copies of fifteenth-century books to be coloured by hand in emulation of pictures in manuscripts. Woodcuts – and later wood-engravings – were made approximately the same height as type so that they could be combined and printed with it. For this reason wood blocks were commonly used for illustrated publications through to the end of the nineteenth century. Page size 300 × 460 mm.

8. Illustrations that were etched and engraved on copper had to be printed separately from typeset text and were therefore costly. The need for refined illustrations in luxury books, particularly of the eighteenth century, sometimes overrode con-siderations of cost, as here in C.-J. Dorat, *Lettres en vers et oeuvres mêlées* (Paris, 1767), with illustrations drawn by Eisen and engraved by De Longueil and others. Page size 176 × 113 mm.

applications. Secondly, the technologies that have been found appro-priate for printing words have for centuries been very different from those suited to printing pictures; it is only in the digital age that we have returned to something like the production unity of the simplest documents made in the past with pen or brush and ink. Lastly, these and other factors have led to printed words and pictures being studied separately, and usually by people from different disciplines.

For the most part, those who made type (punchcutters and typefounders) and set text matter (compositors) worked in entirely different domains from those who drew pictures (artists and illustra-tors) or turned them into printing surfaces (trade engravers and lithographers). In addition, many printers specialized in categories of work that involved either pictures or words. Whereas woodcuts and wood-engravings were commonly printed along with text (fig. 7), all intaglio prints on sheets bearing letterpress text involved a second working on a special press, and this often meant putting work out to another firm (fig. 8).

It was presumably for these reasons that the first manuals devoted to printing divide clearly between those dealing mainly with words and those devoted to pictures. Joseph Moxon's *Mechanick exercises* (London, 1683–4) and Hornschuch's *Orthotypographia* (1608) dealt

respectively with the printing and editing of text; Abraham Bosse's *Traicté des manières de graver en taille douce sur l'airin* (Paris, 1645) and Jean-Michel Papillon's *Traité historique et pratique de la gravure en bois* (Paris, 1766) were concerned exclusively with the making and printing of pictures.

It was not until the late eighteenth century that delicate and detailed pictures could be combined with text conveniently. This was first achieved by using wood-engravings, but towards the end of the nineteenth century photographically produced relief blocks began to take their place. Lithography too helped to bridge the gap between picture-making and word-making technologies in the nineteenth century. Even so, the need to combine high-resolution pictures with lengthy passages of text imposed all sorts of constraints right up to the second half of the twentieth century. It could be argued that these difficulties served to reinforce a bias – seen first in the Renaissance – towards unillustrated books, or at the very least books with token illustrations only.

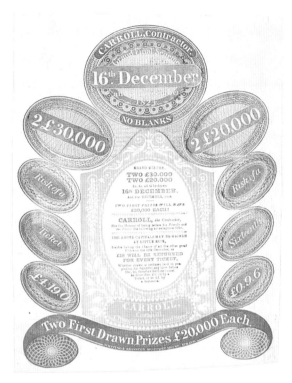

9. Lottery bill printed in 1824 by Whiting & Branston of the Strand, London, for the lottery contractor Carroll. The blue and pink parts were printed together at one pull of the press using the compound-plate process of William Congreve; the yellow printing, which also involved embossing, was printed separately. Image 215 × 169 mm.

Printed artefacts

When we consider printing of the past, there is a good chance that books spring to mind. We have to remind ourselves therefore that printing has never been limited to books. Many other kinds of products, including newspapers, magazines, maps, sheet music, playing cards, religious prints, bookplates, notices, posters, security printing, forms, invitations, packaging, and even more ephemeral items than these, have had a long history in print (figs 9,31,32,50). Some of them go back almost as far in time as printed books, some even further. The concentration on books in this account simply reflects the fact that libraries are primarily repositories of books and that, by definition, items of printed ephemera are unlikely to have been preserved to the same extent as books.

Hand production

The invention in the Far East

If we interpret printing as meaning the multiplication of images on documents, we have to go back to at least the seventh century in China when small Buddhist charms were printed from wood blocks, some of them, it seems, in vast quantities. The transition from such modest documents to more substantial ones is not recorded, but books printed from wood blocks were not uncommon in China in the ninth century. For around a hundred years the *Diamond Sutra* of 868, which was discovered in the early years of the twentieth century, has been considered the earliest datable book of this kind (fig. 10). More recently, earlier printed books have come to light in Korea that have pushed back the beginnings of book printing from wood blocks to at least the mid eighth century.

One requirement of an invention that sought to multiply large numbers of copies from a master image was that there should be a plentiful supply of material on which such copies could be made. This requirement had already been met with the invention of paper in China some two or three centuries before Cai Lun reported on its manufacture to the Emperor in the early second century. There is therefore a gap of many centuries between the invention of paper and the earliest surviving wood-block printing on it. Early Chinese wood-block prints were cut on the long grain, that is on the plank of the wood, and involved the use of water-based inks. Prints would have been taken by placing paper on the surface of the block and striking it with a brush, or rubbing it with a pad or smooth piece of wood. There is no evidence of presses having been used in this period, even though very large numbers of some prints seem to have been produced.

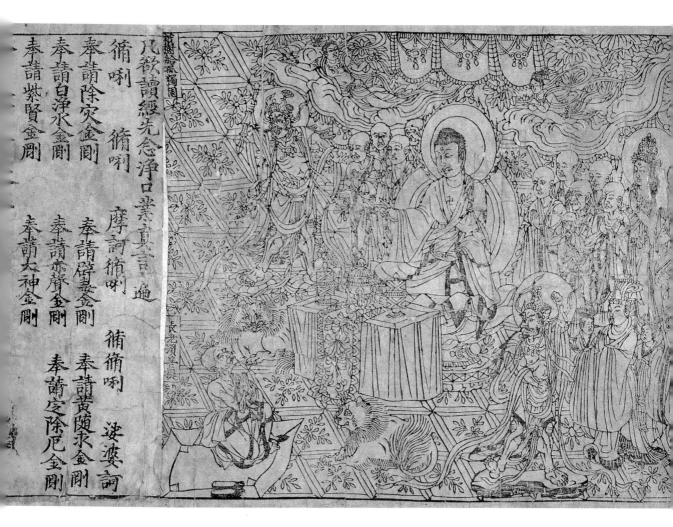

Many of these Chinese wood-block printed items include pictures and words. But even in the case of Chinese books without pictures there would have been no urgent need to consider producing separate re-usable characters. With tens of thousands of different characters in the Chinese language this would have presented formidable problems, both in the manufacture of characters and the selection of them for setting. This was one of the reasons why printing from wood blocks continued for centuries in China and other parts of the Far East: it was a simple and direct means of multiplying both the hand-written marks of the scribe and the drawings of the artist.

The first steps towards making separate re-usable characters that could be combined with one another in different ways were also taken

10. The *Diamond Sutra* (Jingang-jing), dated 868, printed throughout from wood blocks on a paper scroll measuring 265 × 5250 mm. The text is a Chinese version of one of the most important Buddhist writings. The frontispiece is the only illustration in the book.

in the Far East (fig. 11). The man who is credited with this innovation is Bi Sheng, who worked in the first half of the eleventh century. The stages in this development are by no means clear, but it seems that separate characters of either baked clay or tin were used in the first instance. These materials did not prove successful and the early use of movable type that caught on involved cutting characters on a plank of wood and then sawing them up to form individual types. By the beginning of the fourteenth century types made of wood were being

20

used to set whole books. One or two round, revolving tables were used to store the type, which allowed the compositor to locate what was needed relatively quickly. The refinement of this method of printing from movable type is credited to Wang Zhen.

Methods of casting type in metal were also developed in Korea, where they were at first associated with religious communities which used bronze casting for other purposes. The use of casting technology meant that large numbers of identical characters could be manufactured, which helped to speed up production and also increased the uniformity of the characters. The earliest surviving book printed from bronze types in Korea, *Chikchi simch'e yojŏl* [Selected teachings of Buddhist masters], bears a date corresponding to the year 1377. The developments outlined above took place well before the invention of printing from movable type in the West, though there is no real evidence of a link between the two.

The invention in Europe

For more than two hundred years a debate has raged over the invention of printing and, in particular, who was responsible for it. This debate largely ignored developments in the Far East and focused on two Europeans: Laurens Coster from Haarlem and Johann Gutenberg who worked in Strasbourg and Mainz. In this battle for priority, which inevitably had national overtones, Gutenberg has emerged the clear winner. Coster, who worked in the early fifteenth century, was undoubtedly the earlier of the two, but his form of printing probably involved the manufacture of wood letters. Gutenberg's claim to fame was that he invented a convenient method of replicating letters by casting them from matrices in a mould. Though none of his equipment survives and we have no reliable descriptions of it, his matrices must have taken the form of right-reading letters impressed into soft metal, such as copper. The shapes of his letters would have been made by striking pieces of copper with shafts of hardened steel, each one bearing a letter that stood in relief and was wrong reading. These master letterforms, known as punches, had to be cut with great skill and involved a major investment of time. It is thought that Gutenberg must also have invented some form of adjustable type mould, a device that accommodated one matrix at a time and allowed molten metal, consisting primarily of lead, to be poured into a rectangular cavity

11. (OPPOSITE) *Collected commentaries on the Spring and Autumn annals* (Ch'unch'u kyŏngjon chiphae), Seoul, 1434. One of the handsome books printed from bronze types under the patronage of King Sejong (reigned 1418–50). The *Kabin* types used to print this book show the influence of the work of the Chinese calligrapher Zhao Mengfu (1254–1322). Books were printed from movable type in Korea well over half a century before Gutenberg's famous Bible (figs 18,19). Page size 332 × 164 mm.

21

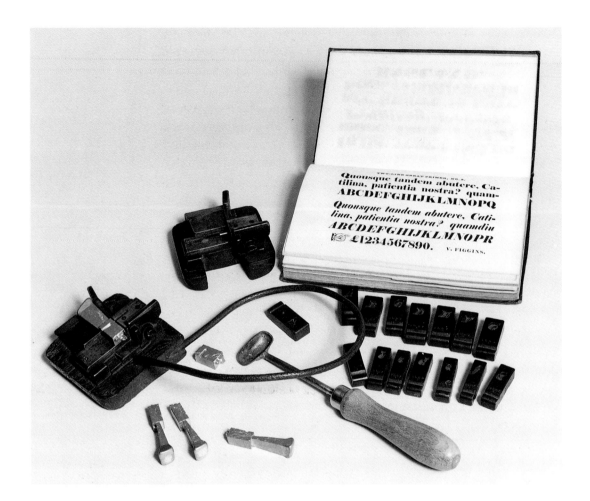

12. Early nineteenth-century items in the St Bride Printing Library, London, that relate to the casting of type by hand. Shown in the middle of the picture are an open mould (one part with a piece of type in place); a ladle for pouring molten metal (consisting mainly of lead) into the mould; and some copper matrices, which would have been fixed into the mould one by one to produce different characters. Bottom left are three pieces of type with their unwanted parts (jets) still attached. Also shown is a type specimen book of the London founder Vincent Figgins.

(figs 12,13). What results from this operation is a piece of type, a shaft of lead with a letterform at one end which, echoing the punch, stands in relief and is wrong reading. The crux of Gutenberg's invention seems to have been that he found a method of adjusting a mould so that the different widths of the letters of the latin alphabet could be produced without doing violence to their proportions (a requirement that manufacturers of typewriters did not take seriously until the mid twentieth century).

Once his types had been cast, Gutenberg must have found a way of bringing them together in lines, putting spaces between words, and making the lines even in length. He is likely to have used a composing stick similar to the wooden devices that have survived from later centuries (fig. 14). Pieces of type would have been picked up singly

22

and arranged in lines in the stick before being transferred to a tray (later called a galley) for temporary storage. The lines of type would then have been formed into pages and fastened into a metal frame (later known as a chase) so that they could be held together on the bed of the press. This assembly came to be known as a printing forme. Gutenberg may not have done precisely what has been described here, but he must have done something similar. He would also have had to devise a means of storing the type before and after use, and it is assumed that this would have been similar to the printer's type case of later years (fig. 15).

The epoch-making nature of Gutenberg's invention – the discovery of a way of replicating individual types that imitated the written forms of the day, including their spacing along the line – is one reason why he is now generally held to be the inventor of printing. He came up with an idea that was robust enough to be adapted to different technologies, including photocomposition and digital setting in the twentieth century. There is no evidence to suggest that Coster invented anything like an adjustable type mould. In so far as we know what his method of printing involved, it was comparable to the early Far Eastern practice of printing from movable wood type. Any claim that printing was invented in Europe has therefore to be founded on Gutenberg rather than Coster.

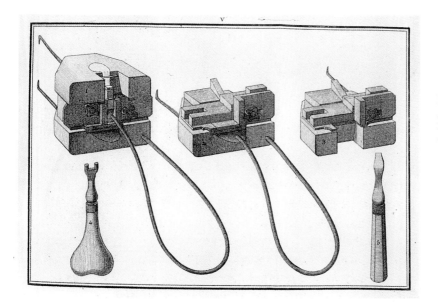

13. Plate from Pierre-Simon Fournier, *Manuel typographique* (Paris, 1764–6) showing, from left to right, a type mould closed, its bottom half shown open, its top half shown open. A key for turning nuts and a screwdriver are shown below. Folding plate 170 × 210 mm.

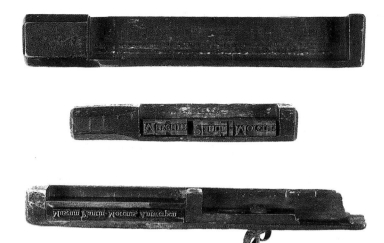

14. Early composing sticks. In the first place (top two examples) they were made to accommodate a particular length of line (measure). Later kinds (bottom) were usually made with a movable part so that they could be adjusted for different measures. By the nine-teenth century adjustable composing sticks were normally made of metal.

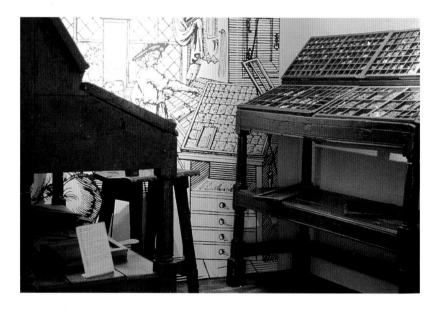

15. Type was stored in wooden trays (cases) throughout the period of hand composition, which lasted well into the twentieth century. Cases were divided into small compartments, one for each character (sort). Later, cases were usually stored beneath the frame. Until the mid sixteenth century printers used one large case. Thereafter, most used a pair of cases, except in German-language countries. One of a pair of cases contained capitals and small capitals, the other small letters, though the arrangement (lay) of the cases varied from one country to another. The position of the two cases on the frame when setting explains the use of the terms 'upper case' and 'lower case' for capitals and small letters.

If we interpret printing as meaning the multiplication of docu-ments, the Far East takes priority over both Coster and Gutenberg by many hundreds of years. Gutenberg's use of a press certainly helped to speed up printing, but it did not represent anything fundamentally new. It may be partly for this reason that scholars in Europe have chosen to interpret the invention of printing as the origination of text matter (that is, the assembly of movable type of different widths cast from an adjustable mould) rather than the multiplication of either

text or pictures. Such an approach secures the invention of printing for Europe: by any other interpretation it was an invention of the Far East.

Early printing

What has survived from the earliest days of printing in Europe are mainly individual pictorial prints, decorative work for printing on cloth, and unillustrated books. Early items of ephemeral printing, such as papal indulgences, have also survived, and so too have block books, a category of book consisting of collections of pictures and text cut on wood. What we know about fifteenth-century printing derives largely from such work.

The first items printed on paper in Europe, as in the Far East, were probably devotional prints (fig. 16). They were produced from wood blocks, and their simple linear style suggests that they were meant to

16. This hand-coloured devotional woodcut of St Christopher, which survived because it was preserved in an early fifteenth century manuscript, bears the date 1423. If this is the date of its production, which seems likely, it is the earliest dated European woodcut.

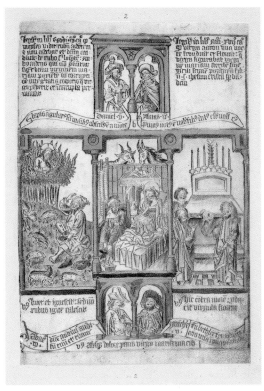

17. Some fifteenth-century books, such as this hand-coloured block book *Biblia pauperum* (*c.* 1460), were printed throughout from wood blocks on one side of the leaf only, using methods not so very different from those used for the *Diamond Sutra* (fig. 10). Block books involved little capital cost, combined text and pictures easily, and the blocks used to print them could be carried around by itinerant craftsmen and printed on demand. These advantages account for their use for popular religious works long after the spread of printing from movable type. The two pages shown are f.2 and f.35. Page size 274 × 213 mm.

be hand-coloured; they would probably have been seen in their day as substitutes for paintings. Likewise, many block books, some of which were adaptations of manuscript versions, have survived in hand-coloured form (fig. 17). In fact, most fifteenth-century printed books were conceived as coloured objects in emulation of manuscripts. Many of them may have come down to us uncoloured, or only partially coloured, but the design and production of the typical fifteenth-century book were predicated on the practice of hand-colouring.

Gutenberg's most famous production, the 42-line Bible, which was underway in 1454 and completed in 1456 or earlier, was originally conceived as a piece of two-colour printing. Copies of the book differ one from another (figs 18,19), but several of the fifty or so surviving copies (of an edition of around 160 or 180) have parts of their first few pages printed in red, in imitation of the rubrication of manuscript books (fig. 19). But it seems that printing in two colours posed too many problems for Gutenberg and his associates at the time.

18. Gutenberg's 42-line Bible, so called because most of its columns of text have forty-two lines, was printed in Mainz in a fairly large workshop around 1453–5. It was certainly complete in 1456. Though books had been printed from movable type in Korea some decades beforehand, the ambitious nature and quality of this production have made it the major landmark in the history of printing. For such early printing it is remarkable for its quality of type, harmonious arrangement of words along the line, and consistency of printing through its 1286 pages. This copy in the British Library has all its red parts and decoration added by hand. Page size 388 × 236 mm.

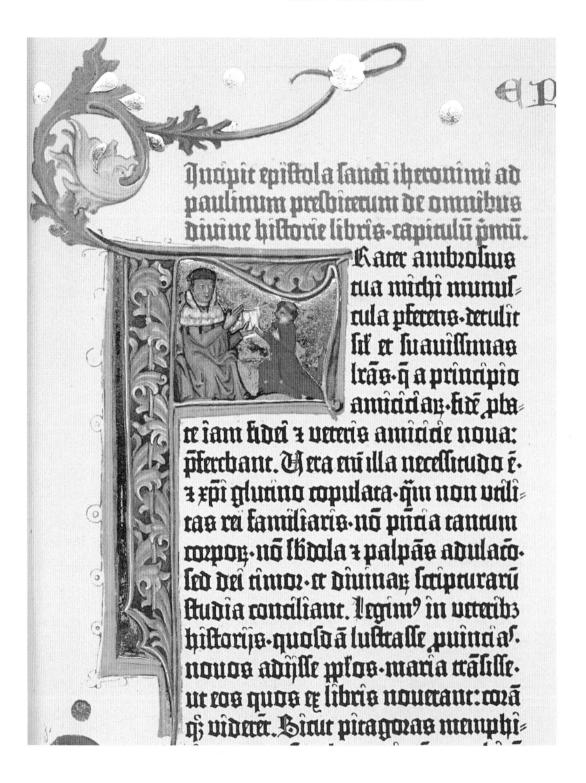

Incipit epistola sancti iheronimi ad paulinum presbiterum de omnibus diuine historie libris. capitulū p̄mū.

Rater ambrosius tua michi munuscula pferens. detulit sī et suauissimas lrās. q̄ a principio amiciciaz. fidē pbate iam fidei z veteris amicicie noua: pferebant. Uera enī illa necessitudo ē. z xp̄i glutino copulata. quī non vtilitas rei familiaris. nō pn̄cia tantum corpoz. nō sb̄dola z palpās adulaco. sed dei timor. et diuinaz scripturarū studia conciliant. legim⁹ in veteribz historijs. quosdā lustrasse puīcias. nouos adijsse pp̄los. maria trāsisse. ut eos quos ex libris nouerant: corā q̄z viderēt. Sicut pitagoras memphi

They must have felt that there were easier ways of emulating the manuscript book, and at a fairly early stage in the production of this Bible they decided that anything in addition to black type would have to be added by hand. In this respect Gutenberg set the pattern for printed books for the rest of the century and into the next. Since early printed books were to a very large degree based on manuscript books and existed alongside them, it would not have seemed strange for the two methods of production to be combined. For half a century or so, therefore, printing from movable type was used for text matter and hand-colouring for decorative purposes and for navigational devices, such as initial letters.

There was one major fifteenth-century exception to the practice of producing coloured books by making manuscript additions. This is the so-called Fust and Schöffer *Psalter,* which was produced in Mainz in 1457 (fig. 20) and reprinted there in 1459. This remarkable book was the work of Gutenberg's successors: his printer Peter Schöffer and his former financial backer Johann Fust. It was an ambitious attempt to

19. (OPPOSITE)
A few copies of Gutenberg's 42-line Bible have some lines printed in red at the beginning of the book, as in this example from the Gutenberg Museum, Mainz. This was probably the production method Gutenberg had in mind originally for the whole publication, but after a few experiments he resorted to leaving space in the black workings for red lines to be added by hand. The illuminated letter and decoration shown in this detail were added by hand.

20. The opening page of a *Latin Psalter,* printed by Fust and Schöffer in Mainz by mid 1457. The book was printed throughout in colours and shows the efforts its printers made to emulate the coloured manuscripts of the time. The book has a series of large decorated letters which were made in two interlocking parts. These parts were inked up separately in different colours and then brought together for printing at one pull of the press to give a perfect fit (register). Page size 354 × 254 mm.

produce, by the new technology of print alone, something that conformed to the colourful manuscript model of a church service book. The main feature of the *Psalter* is a series of large initial letters, printed in two colours. There has been discussion for centuries about their production, but it seems clear that it involved the use of blocks consisting of two interlocking parts which were inked up separately in different colours and then brought together to be printed along with the text at one pull of the press. It was a method that anticipated the nineteenth-century colour printing process of compound-plate printing (*see* fig. 9).

The fact that Gutenberg and most other early printers took one route through to producing coloured books, and Fust and Schöffer another, suggests that no clear technical solution to the problem of making multiple copies of books that met reader expectations in terms of colour had yet been found.

The monochrome book

The success of printing inevitably brought changes in both design and production methods, since hand-colouring proved incompatible with the multiplication of large numbers of documents. Despite the ambitious example of the Fust and Schöffer *Psalter*, colour printing was not the route to be followed in the short term. Instead, ways were found of producing books that worked perfectly well in their monochrome state. The change was a gradual one and came about in the hundred years following Gutenberg's invention. In this period hand additions were usually planned for by leaving spaces for initial letters at the beginning of sections and paragraphs; but as the decades wore on, more and more copies of books were published without their hand-colouring (fig. 21). In the first instance, therefore, books became monochrome by default.

It was in the second quarter of the sixteenth century that the monochrome book really came of age. In this period, and particularly in Paris, books were produced that worked very well by using typographic devices instead of colour to help readers find their way around even extremely complex texts. One of the leading figures in this respect was the Paris scholar and printer Robert Estienne (1503–59), who made use of printed initial letters and a range of different sizes of type, italics, and small capitals to make distinctions between different

classes of material or to distinguish specific groups of words from others. He also used a variety of cross-referencing systems and effectively established the versification of the Bible. He stands out from many of his contemporaries because he was at the forefront of a shift in thinking about printing which has influenced typographic design and book production ever since (fig. 22).

Though certain categories of book, mainly service books, have conventionally been printed in red and black, the monochrome book continued to satisfy the needs of most readers until the second half of the twentieth century. The coloured book began to re-emerge with the rise of commercial colour printing in the nineteenth century, though in this period colour was mainly used for pictures and decoration. But for good technical and perceptual reasons, black has always been the favoured colour for text matter.

For something like three centuries, the methods used for printing the text pages of books hardly changed at all. The various activities associated with printing became more refined as the years went by,

21. Printers of early sixteenth-century books sometimes continued the earlier practice of leaving spaces for initial letters to be added by hand. Paolo Giovo, *Vita Sfortiae* (Rome, 1539), printed by Antonio Blado, is a late survivor of this custom. This particular copy, which shows guide letters for the rubricator, was never coloured, presumably because this would have been regarded as both costly and unnecessary. Page size 222 × 155 mm. It is worth noting that this book was printed a decade after Robert Estienne's *Biblia* (fig. 22).

22. Robert Estienne was one of several printers working in Paris in the second quarter of the sixteenth century who developed methods of articulating texts visually without the use of colour. His *Biblia* (1527–8) was a remarkable work of scholarship which provided strong visual and other guides to help readers find their way around the text. These included initial letters (printed from blocks), a range of four sizes of type, and small capitals. In a later edition of the Bible he numbered verses and effectively established a convention that has lasted ever since. The edition shown here is foliated rather than paginated, which means that only the right-hand page (recto) of this double spread is numbered. Page size 382 × 227 mm.

HIERONYMI PRAEFATIO IN LIBROS SALOMONIS.

IVNGAT epistola quos iungit sacerdotium:imò charta non diuidat quos CHRISTI nectit amor.Commentarios in Osee,Amos,& Zachariam,Malachiam quoque poscitis.scripsissem si licuisset præ valetudine. Mittitis solatia sumptuũ notarios nostros & librarios sustentatis,vt vobis potissimum nostrum desudet ingenium.Et ecce ex latere frequẽs turba diuersa poscentium:quasi aut æquum sit me vobis esurientibus,aliis laborare:aut in ratione dati & accepti,cuiquam, præter vos,obnoxius sim.Itaque longa ægrotatione fractus,ne penitus hoc anno reticerem,& apud vos mutus essem, tridui opus nomini vestro consecraui,interpretationem videlicet trium Salomonis voluminũ, MISLE,quod Hebræi Parabolas,vulgata autem editio,Prouerbia vocat: COHELETH, quẽ græce ecclesiasten,latine concionatorem possumus dicere: IRHASIRIM, quod in lingua nostra vertitur,Canticũ Canticorum.Fertur & panæretos Iesu filij Sirach liber,& alius pseudepigraphus,qui Sapientia Salomonis inscribitur. Quorum priorem,hebraicum reperi,non ecclesiasticum vt apud Latinos,sed Parabolas prænotatum.cui iuncti erant, Ecclesiastes & Canticum Canticorum:vt similitudinem Salomonis,non solum numero librorum,sed etiam materiũ genere coæquaret.Secundus, apud Hebræos nusquam est.quin & ipse stylus, Græcam eloquentiam redolet:& nonnulli scriptorum veterum hunc esse Iudæi Philonis affirmant.Sicut ergo Iudith,& Tobiæ, & Machabæorum libros legit quidem ecclesia,sed eos inter canonicas scripturas non recipit:sic & hæc duo volumina legat & ædificationem plebis,non ad authoritatem ecclesiasticorum dogmatum confirmandum. Si cui sanè septuaginta interpretum magis editio placet,habet eam à nobis olim emendatam. Neque enim noua sic cudimus, vt vetera destruamus.Et tamen cum diligentissimè legerit,sciat magis nostra scripta intelligi,quæ non in tertium vas transfusa coacuerint,sed statim de præslo purissimæ commendata testæ,suum saporem seruauerint.

LIBER PROVERBIORVM, QVEM HEBRAEI MISLE APPELLANT.

CAPVT I.

Tit⁹ libri. A

PARABOLAE Salomonis filij Dauid regis Israel: ad sciendam sapientiam & disciplinã, ad intelligẽda verba prudentiæ,& suscipiendam eruditionem doctrinæ, iustitiã, & iudiciũ, & æquitatẽ: vt detur paruulis astutia,adolescenti scientia, & intellectus.Audiens sapiens,sapientior erit: & intelligens,gubernacula possidebit:animaduertet parabolam & interpretationem, verba sapientum, & ænigmata eorum. Timor domini, principiũ sapientiæ.Sapiẽtiam atque doctrinam stulti despiciunt.Audi fili mi disciplinam patris tui,& ne dimittas legem matris tuæ,vt addatur gratia capiti tuo,& torques collo tuo.Fili mi,si te lactauerint peccatores, ne acquiescas. Si dixerint, Veni nobiscum,insidiemur sanguini, abscõdamus tendiculas contra insontem frustra,deglutiamus eũ sicut infernus viuentem,& integrum quasi descendentem in lacum:omnem pretiosam substantiã reperiemus,implebimus domos nostras spolijs, sortem mitte nobiscum, marsupium vnum sit omnium nostrum:fili mi ne ambules cũ eis, prohibe pedem tuum à semitis eorum.Pedes enim illorum ad malum currunt,& festinant vt effundant sanguinem.Frustra autem iacitur rete ante oculos pennatorum.Ipsi quoque contra sanguinem suum insidiantur,& moliuntur fraudes contra animas suas: sic semitæ omnis auari animas possidentium rapiunt.Sapientia foris prædicat, in plateis dat vocem suam:in capite turbarũ clamitat, in foribus portarum vrbis profert verba sua,dicẽs, Vsquequo paruuli diligitis infantiam,

& stulti ea quæ sibi sunt noxia cupiunt,& imprudentes odibunt scientiam?Conuertimini ad correptionem meam: en proferam vobis spiritum meum,& ostendam vobis verba mea. Quia vocaui,& renuistis:extendi manum meam,& non fuit qui aspiceret: despexistis omne consilium meũ,& increpationes meas neglexistis:ego quoque in interitu vestro ridebo,& subsannabo,cum vobis id quod timebatis aduenerit.Cum irruerit repentina calamitas,& interitus quasi tempestas ingruerit: quando venerit super vos tribulatio & angustia:tunc inuocabunt me,& non exaudiam: mane consurgent,& non inuenient me:eò quòd exosam habuerint disciplinam,& timorem domini non susceperint,nec acquieuerint consilio meo,& detraxerint vniuersæ correptioni meæ. Comedent igitur fructus viæ suæ, suisque consilijs saturabuntur.Auersio paruulorum interficiet eos,& prosperitas stultorum perdet illos. Qui autem me audierit,absque terrore requiescet,& abundantia perfruetur, timore malorũ sublato.

Esa. 65.b. ie re.7.c.

CAPVT II.

D

Fili mi, si susceperis sermones meos, & mandata mea absconderis penes te, vt audiat sapientiam auris tua: inclinabis cor tuum ad cognoscendam prudentiam. Si enim sapientiam inuocaueris,& inclinaueris cor tuum prudentiæ, si quæsieris eam quasi pecuniã,& sicut thesauros effoderis illam: tunc intelliges timorem domini,& sciẽtiam dei inuenies.quia dominus dat sapientiam, & ex ore eius prudentia & scientia.Custodiet rectorum salutem,& proteget gradientes simpliciter, seruãs semitas iustitiæ, & vias sanctorum custodiens. Tunc intelliges iustitiam & iudiciũ, & æquitatem,& omnem semitam bonam. Si intrauerit sapientia cor tuum,& scientia animę tuę placuerit: consilium custodiet te, & prudẽtia seruabit te vt

Monet sapien
tiã amplecten
dã,quæ timo
rẽ domini do
ceat.

Cõmentario
sapientiæ quæ
est virtũ dei,
& qui sit vsus
eius.
Psal.ũ.d
eccl.s.b

Ideirco pec
catu nõ acquiescendum.
B

Esa. 59.b.

Cõparantur C
sapientia se ab
cibus contẽni.

33

but there were remarkably few innovations. Most obviously, types were manufactured to closer tolerences, which meant that they could be cast in smaller sizes than in the early days of printing. This had the dual advantage of allowing for a wider range of type size in printed matter and smaller artefacts. Nevertheless, punchcutters and type-founders of the late eighteenth century would probably have been perfectly at home working in a type foundry of the early sixteenth century.

The biggest change in the appearance of books as artefacts came with the gradual reduction in their size. Large-format books continued to be produced for particular purposes, but the reduction in size of the average book, which began in the late fifteenth century, must have become particularly noticeable by the seventeenth century. It was made possible by the development of a greater range of smaller types and by printing eight, twelve, sixteen, twenty-four, thirty-two, or even more pages together on one side of a sheet of paper. The small-format books published in the Low Countries in the seventeenth century by the Elzevirs, with their dense pages of tiny type, would not have been technically possible a century earlier.

Such developments led to the inclusion of imposition schemes in technical manuals on printing. These are plans for the arrangement of the pages of a book so that they appear in the right sequence when the sheet on which they were printed (on both sides) was folded and trimmed (fig. 23). Most books would have needed many such sheets which, in their folded form, are called sections (sometimes gatherings or quires). Scores of different imposition schemes were developed for different book formats and, following an earlier manuscript practice, each sheet was 'signed' (with a letter or number) to make sure that it was brought together in the right sequence for binding.

23. Hieronymus Hornschuch, *Orthotypographia* (Leipzig, 1608) was written for correctors of the press (who combined the roles of what today might be called editors and proof-readers). His book included sets of imposition schemes showing the arrangement of pages on the sheet as they should come off the press. They helped the corrector to make sure that pages appeared in the right sequence when the sheet was folded and cut. This arrangement of 8 leaves or 16 pages is for an octavo-format book. Later printing manuals showed imposition schemes in terms of formes of type, because this was how the printer needed to know them.

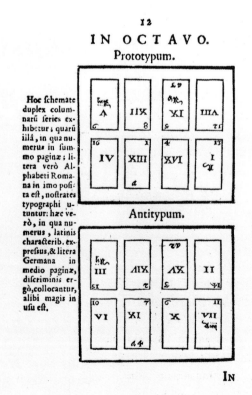

Technical improvements continued to be made in the manufacture of type and type ornaments, in refining the printing press, in the making of inks, and in the methods used for taking prints. But it is unlikely that they would have been noticed by readers until a period of self-consciously fine printing dawned in the second half of the eighteenth century with Baskerville, Bulmer, and Bensley in Britain, Bodoni in Italy, and the Didots in France.

The growth of illustration

In the centuries before 1800 significant changes were made in pictorial work, the earliest of which related to cutting on wood. Initially woodcut images were produced as simple outline prints which would not have been considered complete until coloured by hand. The shift towards woodcut images that relied more on monochrome hatching than hand-colouring was a gradual one, but it was given tremendous impetus by the efforts of one man: the Nuremberg artist Albrecht Dürer (1471–1528). He was brought up as a craft woodcutter and for a time worked on the popular world history generally known as the *Nuremberg Chronicle* (1493) (*see* fig. 7), but within a few years he had transformed woodcutting into a powerful medium for the artist. In technical terms, his major achievement was to convert a process that had been used as a first stage in the production of hand-coloured illustrations to an effective monochrome process. He did this by demonstrating how hatched lines could be made on wood to create form, and at the same time suggest both tone and texture. He gave printing ink an extra dimension, and in his *Apocalypse* of 1498 took woodcutting to new heights of expression (fig. 24). As it happens, the techniques he and others of his time must have used were very similar to those described almost three hundred years later by Papillon in the very first published treatise on woodcutting (*see above* p. 17).

Woodcuts were well suited to book production because they could be placed alongside type matter and printed with it. This was a considerable economy compared with the other widely used form of illustration, engraving on copper, which was much slower at the multiplication stage and involved a second working using a special kind of press. On the other hand, copper-engraving was a more refined process than woodcutting and, where precision and quality were required, was the most suitable process to use. It was explored to

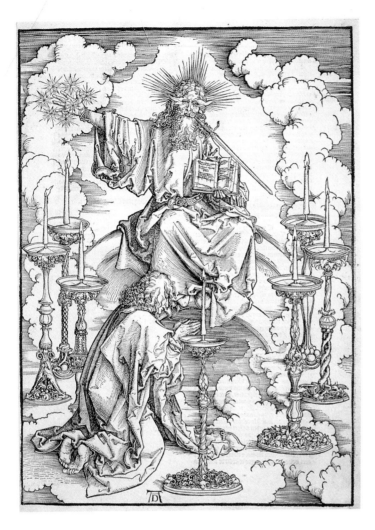

24. 'The vision of the seven candle-sticks' by Albrecht Dürer. One of fifteen full-page woodcuts he designed and probably cut for German and Latin editions of the *Apocalypse* (1498). Using the same methods as earlier woodcutters, Dürer transformed the woodcut into an expressive monochrome process by his skilful use of hatching to convey tone, form, and texture. Image size 394 × 287 mm.

25. Details of Dürer's woodcut 'The vision of the seven candlesticks' (fig. 24) and of his copper-engraving 'St Jerome in his study' (1514), both shown to the same scale. The difference in the delicacy of the marks that could be made using the two processes led Dürer to turn to woodcut for narrative and didactic subjects and copper engraving for more descriptive and naturalistic ones. Both 92 × 126 mm.

good effect in prints of the fifteenth and sixteenth centuries, but in that period was used less frequently in books. In Dürer's hands it allowed for a delicacy of handling that even he could not achieve in woodcutting (fig. 25). The two picture-making processes of the period offered very different opportunities: woodcutting was relatively crude but was quick at the multiplication stage and could be used for long runs; copper-engraving was refined but was slow at the multiplication stage and could be used for long print runs only with regular retouching.

For the reasons given above, illustrations presented more of a problem than text for those who printed from relief surfaces (letter-press printers). One such person who found ways of introducing illustrations into his books on a regular basis was Christopher Plantin (died 1589), who worked for most of his life in Antwerp as a printer and publisher. He and his successors made good use of the flourishing trade of copper-engraving that had been nurtured locally by the carto-graphic trade, while continuing to use woodcuts when they were more appropriate. Thousands of their original wood blocks and copper plates survive in the Plantin-Moretus Museum in Antwerp.

As intaglio printing began to be used widely for commercial pur-poses, etching on copper, which had been used by Rembrandt and other seventeenth-century painters for the freedom of expression it offered, began to be seen by illustrators as a quicker and easier method than engraving for commercial work. Etching involved coating a copper plate with an acid-resistant ground, drawing on this with a sharp tool so as to expose the surface of the plate, and then immersing or washing the plate with acid to convert the drawn marks into hollow lines. These lines could be made deeper by controlling the amount of exposure to the acid. In the middle of the seventeenth century Abraham Bosse (1602–76) developed a method of etching on copper using a harder acid-resistant ground and a special rounded tool which could be used to imitate the effects of copper-engraving (fig. 26). This had considerable commercial advantages as it meant that images could be made to look like engravings on copper – the most prestigious form of printed picture at the time – and yet be produced more easily. Usually the final touches to such etchings were made with the engraver's burin. From about this time it became common commercial practice to begin work on an intaglio plate by means of etching, and finish it off by engraving. Such prints are usually called engravings, even though most of the work may have been etched.

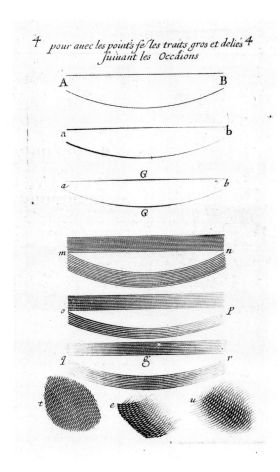

26. Plate from Abraham Bosse, *Traicté des manières de graver en taille douce sur l'airin* (Paris, 1645). Bosse wrote the first manual on intaglio engraving and used it to explain his method of producing etchings with swelling and tapering lines that imitated those of the copper engraver.

Both engraving and etching rely on lines of varying strength, and occasionally dots, to create tones optically. Their tonal equivalents, mezzotint and aquatint, were developed in the seventeenth and eighteenth centuries respectively. The initial stage of mezzotinting involved the slow mechanical pitting of a copper plate with a tool called a rocker so that, if left in this state, it would print black all over. The image was produced by burnishing down the plate's surface: the smoother it became, the lighter it printed. Aquatint involved depositing pelicules of resin on the plate (either by forcing them into the air within a box and allowing them to settle, or by holding them in suspension in a liquid that evaporated). The resin pelicules protected the plate and the image was controlled by applying acid resist to parts of the plate and then etching it. This process was repeated several times to produce a series of different tones. Both mezzotint and aquatint had limited applications as they were not able to withstand long print runs: mezzotint was at its most effective when dark images were needed, and tended to be used for the reproduction of portraits; aquatint was particularly appropriate for the reproduction of the lighter tones of landscape and topography.

Printing presses

Little is known about the presses used by the very earliest letterpress printers, though it is supposed that Gutenberg's presses derived from the wine press, which dates back to ancient Roman times. There are early illustrations of printing presses (fig. 27), but no surviving press dates from before the mid sixteenth century. In the eighteenth century improvements were made to presses used by letterpress printers, but in essence the press used for relief printing remained the same for three hundred years.

Such presses were made almost entirely of wood and are known as common presses. Over seventy common presses survive, seven of them in the Plantin-Moretus Museum in Antwerp (fig. 28). No two are quite the same as they were made, presumably on demand, by jobbing carpenters. Nevertheless, their working mechanisms were essentially the same (frontispiece and figs 28,29). The main components of all common presses were two horizontal surfaces placed one above the other. On the lower one sat the printing forme (consisting of type and, possibly, wood blocks); the upper one could be moved up and down and applied pressure to

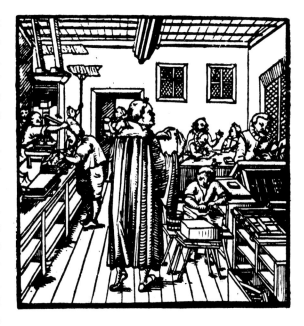

the forme. The lower surface is known as the coffin or bed, the upper one as the platen. The bed could be moved beneath the platen on rails by means of a winch, which was turned by a handle (rounce). The most complex part of the press consisted of a box-like structure (hose), within which was a threaded wooden spindle which rotated in a metal nut; the spindle had a long lever (bar) attached to it so that it could be turned. Together these parts provided the means of applying pressure to the platen. Originally the amount of pressure such presses could deliver was probably not great enough to print a whole forme. This acounts for the fact that the platen was made smaller than the bed and that two pulls were needed to print a whole forme, each covering half of it. Two interlocking metal frames, which were hinged to the outer end of the bed, allowed the paper to be brought down across the forme of type in the right position when the bed was clear of the platen. They also helped to keep it clean. The outer frame (tympan) had a covering that softened and equalized the pressure from the platen; the inner frame (frisket) held the paper in position while both frames were folded down across the bed.

Until the early nineteenth century type was inked up with two leather-covered balls, which were stuffed with wool or horse hair. Each impression involved inking the type, placing the paper on the tympan, bringing down the frisket, lowering the tympan and frisket,

27. An early representation of a printing house from Hieronymous Hornschuch, *Orthotypographia* (Leipzig, 1608). It shows the master printer explaining something in the foreground, several compositors, the corrector in his ruff to the right, the pressman pulling the bar of his press (which is braced to the ceiling), an assistant with a long pole (peel) lifting a printed sheet on to a line to dry. The seated figure in the foreground appears to be damping paper.

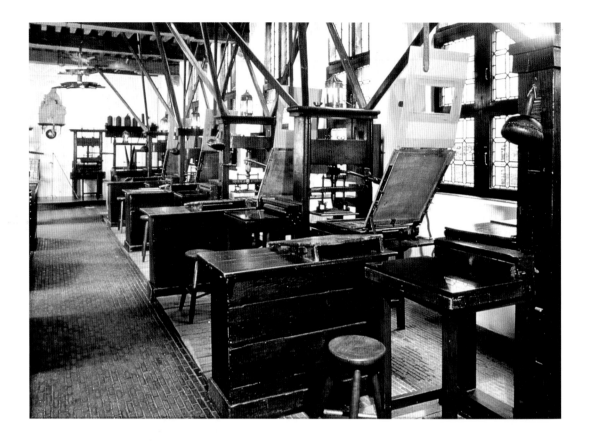

28. The press room of the Plantin-Moretus Museum in Antwerp showing seven common presses. The two oldest (at the far end of the room) may contain parts that date from the sixteenth century, but must have been modified in the seventeenth century. This printing office was used by Christopher Plantin during the latter part of his career, but was further developed by his successors, the Moretus family. It continued in use as a printing house until 1867, and ten years later was opened as a museum.

moving the bed of the press beneath the platen by turning the rounce, and pulling the bar of the press to apply pressure. To remove the sheet a similar set of actions was needed in reverse. Two printers worked in turn inking the forme and pulling the bar of the press, sometimes with the help of a boy who, often daubed with ink, came to be known as a printer's devil. The speed of working on a common press would have been governed by many factors, including the nature and quality of the work and the size of the sheet to be printed, but is likely to have been in the region of two hundred impressions an hour.

The common press was used for printing type and woodcuts; it was not at all suitable for taking impressions from intaglio plates because it did not produce sufficient pressure. The solution to this problem was the rolling press, which applied pressure successively across a plate's surface by means of a cylinder (fig. 30). The early history of the rolling press is obscure, but a few examples survive from the seventeenth century or thereabouts that are made entirely of wood. They consist of

40

two cylinders placed one above the other on either side of a wooden plank. A star wheel attached to one of the cylinders allowed the plank with the plate on it to be pulled though the press. This meant that much greater pressure could be applied to a given area than when using a common press, given the same amount of energy. This was necessary because printing from intaglio plates involved removing ink from hollowed out lines. In order to make this more effective, the printing paper was very thoroughly damped; it was then placed on the inked-up plate and covered with a thick flannel blanket. Inking up a plate involved forcing ink into the engraved or etched lines with a dabber and then wiping its surface clean in such a way as not to remove the ink from the lines. It was very much slower than inking a relief surface. Making intaglio plates and printing from them was therefore more expensive than relief printing from blocks, and for this reason was not as commonly used, except for pictorial prints and prestige work.

29. (BELOW LEFT) Plate from Joseph Moxon, *Mechanick exercises on the whole art of printing* (1683–4), showing an improved kind of press said by Moxon to be the work of Willem Blaeu of Amsterdam.

30. (BELOW RIGHT) Plate from Abraham Bosse, *Traicté des manières de graver en taille douce sur l'airin* (Paris, 1645). It shows an intaglio printer working on a wooden rolling press in a way that suggests that considerable effort was needed to apply pressure to the plate. Printed sheets are shown hanging up to dry as in the early view of a letterpress house (fig. 27).

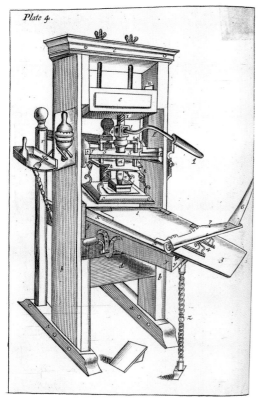

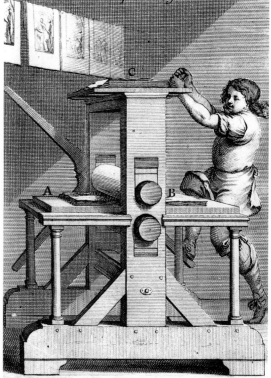

The greatest drawback of intaglio printing was that it was devised with picture making in mind and did not easily lend itself to text matter, even though it was occasionally used for complete books. When it was combined with letterpress text, as it sometimes was, intaglio printing involved an additional working (*see* fig. 8). This alone was a significant limitation to its use in books.

Matching process to job

The marked differences between relief and intaglio printing in terms of speed and cost of production on the one hand, and refinement of work on the other, led to significantly different applications. Routine printing that consisted mainly of text matter was likely to be done from relief surfaces, particularly when large quantities were needed (fig. 31). Prestige printing that involved refined pictorial and decorative work tended to be printed from intaglio plates (fig. 32). Consequently, books, broadsheets, newspapers, proclamations, and notices were nearly all printed letterpress (with woodcut illustrations as necessary), whereas collections of views, scientific illustration, high-class invitations, bookplates, and trade cards, were normally printed intaglio. There were plenty of exceptions to these very broad generalizations, but whether a printed item had a writer or an artist as its main originator had a substantial influence on the method of production used. In time, particular printing workshops began to be associated with certain kinds of products, and this helped to reinforce the distinctions described above.

Two special categories of work, map and music printing, exemplify a general shift from relief to intaglio printing in response to a need for greater refinement. Though they are very different from one another in many respects, they have several production constraints in common. The earliest printing in both fields was from wood blocks, the prints from which could be included in books or book-like items along with text. This method soon proved unsatisfactory for map production, which demanded higher resolution as more and more topographical information became available and the need for accuracy increased. In particular, it was not easy to accommodate words on woodcut maps: when cut on wood they looked crude, but when using the alternative method of inserting type into holes cut into the block it was difficult to curve lettering around geographical features.

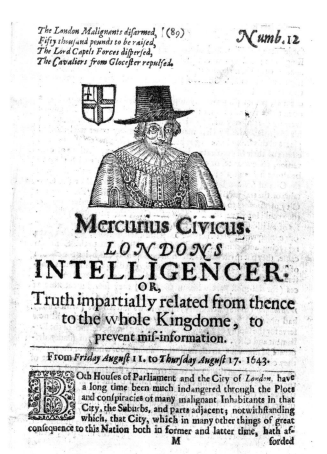

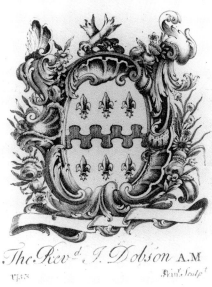

31. (LEFT) *Mercurius Civicus. Londons Intelligencer*, 11–17 August 1643, one of over a dozen weekly newspapers published in London during the Civil War. Relief printing was well suited to newspaper production and early examples often included a simple woodcut illustration.

32. (ABOVE) Intaglio-printed bookplate of the Revd J. Dobson. This bookplate is unusual in bearing both a date, 1753, and the name of its engraver, J. Skinner. Image 95 × 75 mm.

The use of wood blocks for music printing did not last long either, and by the early sixteenth century fonts of music type were available for letterpress printers. The main advantage of typeset music was the convenience with which it could be combined with words. Its main disadvantages lay at the origination stage, both in the large number of sorts that had to be cast and in their composition. In practice, typesetting turned out to be economical for music only when long print runs justified the expense at the composition stage. The technique that came to dominate music publishing was an intaglio method that involved working on metal plates by a combination of scoring, punching, and engraving: staves were scored, noteheads and some other standard elements punched, and words either engraved or punched. This method evolved over the centuries and continued in use well into the twentieth century as far as origination was concerned.

33. Detail from G. F. Handel, 'Messiah', which was printed intaglio from punched and engraved plates and published in London by Arnold, *c.* 1790. It is compared here with the much greater density of information in a detail of the north Kent coast from the first One Inch to a Mile Ordnance Survey map, which was etched and engraved by Thomas Foot and published by W. Faden in 1801. Both 90 × 115 mm.

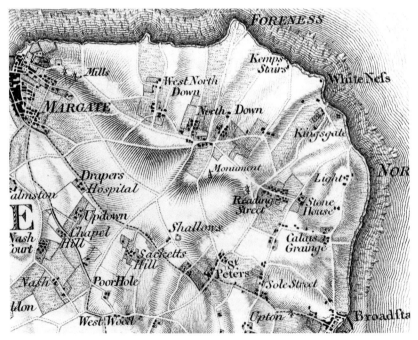

The major problem with both map and music printing was that print runs were often extremely small. On occasions the need at a given time could be measured in tens of copies rather than hundreds or thousands. In addition, whatever process was used to meet this need had to be flexible enough to accommodate an enormous range of graphic possibilities. Intaglio printing met these needs and, consequently, proved to be the most satisfactory process for both map and music printing for centuries (fig. 33). Intaglio plates had the added advantage that they were relatively easy to store and that prints could be taken from them almost on demand (which meant that maps could be updated regularly). Though intaglio printing continued to be used for both map and music publishing well into the twentieth century, by the second half of the nineteenth century it had become common for intaglio-printed proofs of maps and music to be transferred to lithographic stones or plates for speed and economy at the multiplication stage.

Innovation and proliferation

New opportunities

The history of printing up to the end of the eighteenth century can be charted without too much misrepresentation through book production. Other kinds of printed items were common enough before this, but with the exception of maps, music, wallpaper, and fabric printing the book – with its various requirements for text and illustrations – tended to define the technological requirements of printing. By the beginning of the nineteenth century this had ceased to be the case.

The rapid growth of industry and trade from the close of the eighteenth century onwards placed new demands on printers and printing. This was so over much of Europe and the east coast of America, but nowhere was it more obvious than in Britain. Trade, particularly outside the local community, brought the need for advertising and packaging. And as society became more complex and goods and people moved around, all kinds of paper items were produced to satisfy its needs, such as stationery, forms, banknotes, tickets, timetables, catalogues, and, later, postage stamps. Some of these items could be printed using the well tried methods of the past, but increasingly they could not. This was partly because they were needed in much greater quantities and more quickly than before, but also because the older methods did not always fulfil the demanding technical requirements of a society that was making, or had already made, so many advances in science and technology. There was clearly a need for change in printing methods and the spirit of the age encouraged it.

Lithography: an entirely new process

The most significant new development in printing turned out to be lithography. The process was invented – discovered might be a more appropriate term – by Alois Senefelder in Munich around 1798. His intention was simply to find a cheaper way of printing his own writing, but he ended up by determining the process most printers were to use in the second half of the twentieth century. He stumbled on the idea of using stone as a printing surface simply because he had a piece of compact Bavarian limestone in his workshops which he was using as an inking slab. After a time it dawned on him that he could use this as a printing surface and, in the manner of many inventors, he started by exploring existing ideas. At first he tried etching limestone to produce either an intaglio or a relief surface. Eventually, after countless experiments, he arrived at a method of taking prints from stone that did not depend on a difference of relief between the printing and non-printing areas.

Senefelder's process relied on chemical differences between these two areas. The image to be printed was produced on compact limestone with a greasy substance which had an antipathy to water. When the stone was damped, the water was rejected by the greasy marks, but attracted by the porous stone. The reverse was the case when greasy printing ink was applied to the damped stone. This capacity of grease and water to repel one another is encapsulated in the expression 'like water off a duck's back', and was the essence of Senefelder's process. Originally he called it chemical printing, though before long the word lithography and its foreign-language variants (mostly derived from the Greek word for stone) were being widely used to describe the process. Though stone is no longer used commercially, the process is still called lithography; it is classified as a planographic process because it does not rely on differences of relief.

In much the same way that Senefelder tried applying existing processes to stone, his search for an appropriate press for his new method of printing began by adapting features of the common press and the rolling press. But it was not long before he realized that he would have to start from scratch. The requirements of printing planographically from stone were very different from those of relief printing, because the whole of the stone's surface had to be subjected to pressure. In this respect they were more like those of copperplate

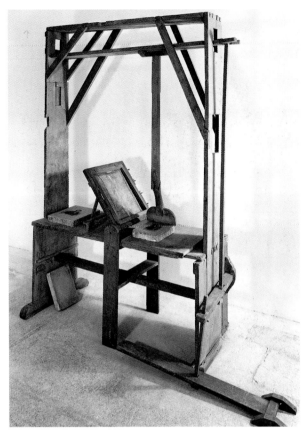

34. The only surviving example of Alois Senefelder's pole press, now in the Deutsches Museum, Munich. Senefelder devised this kind of press in the course of perfecting his invention of lithography at the close of the eighteenth century. It was made entirely of wood and applied pressure to the stone by means of a scraper attached to a long pole. The scraper was pulled across the stone, but with the tympan (shown here folded back) lying across it so that the back of the paper was protected.

printing. The snag was that the stone was fragile and likely to break when the inflexible cylinders of the rolling press of the copperplate printer were used.

Senefelder therefore came up with an entirely new kind of printing press that made use of the time-honoured idea of taking a print by rubbing the back of the paper with a flat instrument. His solution was to fix a wooden scraper to a long pole; this was hinged to a beam which, in turn, formed part of a large box-like frame (fig. 34). The bottom of this structure consisted of a bench on which the stone was placed. By treading on a peddle, which was linked to a series of levers, the scraper could be forced against the stone. The paper to be printed was brought down across the stone by means of a tympan and frisket, which were modelled on such devices used on common presses of the time. The leather-covered tympan protected the paper from the action of the scraper, and had to be well greased to allow the scraper to be pulled across the stone under pressure. Senefelder called this first kind of lithographic press a pole press, and it was used by him and other lithographers for decades for certain kinds of work.

Other kinds of lithographic press were soon developed, nearly all of which made use of some kind of wooden scraper to apply pressure. The solution that eventually found most favour was one in which the scraper was fixed within a beam. The bed of this kind of press, with the stone on it, was pulled beneath the scraper and its beam by turning a handle or star wheel (fig. 35). Lithographic printing on a hand press was considerably slower than letterpress printing, not so much because of the constraints of the press, but because the operation of taking a lithograph involved both damping the stone and inking it up. Outputs of anything between 40 and 120 impressions an hour would have been typical in the period of the lithographic hand press,

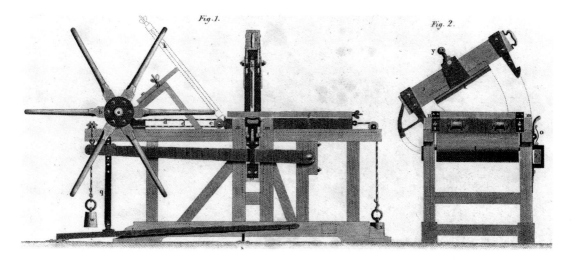

depending on the size and complexity of the work. Such outputs were substantially faster than those achieved by copperplate printers. Gradually, and more rapidly from the end of the nineteenth century, cumbersome slabs of lithographic stone were replaced by metal and composition plates (both of which had been tried by Senefelder). Lithographic stone is no longer used by the printing trade, though it lingered on in a few old-fashioned commercial printing houses through to the middle of the twentieth century.

Lithography was slow to make its mark and, outside Germany, its impact on the printing trade was minimal until the 1820s. It was only around 1820 that it spread to other parts of the world, including America, India, and Russia. In the early years of the century the process excited artists, who saw it as a means of multiplying their own drawings as if by magic and without the intervention of a professional engraver. From the 1820s, however, it began to make inroads into the work of the letterpress and copperplate printer, particularly at the cheaper end of the market. It proved particularly suitable for maps, plans, and short-run printing that combined simple pictures with words. Work that needed to look a little personal, such as circulars, also fell naturally into the lap of the lithographic printer because of the ease with which handwriting could be reproduced by the transfer process (fig. 36). Later, this facility was extended to the production of books, particularly do-it-yourself publications; in this respect lithography can be seen as the forerunner of the desktop publishing revolution of the mid 1980s.

35. A star-wheel lithographic press of the early 1820s belonging to the British lithographer C. J. Hullmandel. Two of several drawings of his press that were used to illustrate an article on lithography in a supplement to the 6th edition of the *Encyclopaedia Britannica* (1824). The press worked on a different principle from the pole press: it had a fixed scraper and the bed (with the stone on it) was drawn beneath it by turning the star wheel.

49

36. Lithographically-printed circular letter, written on transfer paper in his own hand by Lord Althorp on 7 April 1831. The writing was transferred to stone and printed in 200 copies for circulation from Downing Street to drum up support for the Reform Bill. Though this circular did not achieve its desired end, the Reform Bill was eventually passed in 1832. Shown front and back, 240 × 190 mm.

Lithography is referred to first among the printing innovations of the late eighteenth and early nineteenth centuries because it turned out to be the most significant in the long run. It was not the earliest, however, and others might have seemed just as important at the time.

Wood-engraving: pictures for mass markets

One such innovation was wood-engraving, which was perfected by Thomas Bewick (1753–1828) in the late eighteenth century, and was a refinement of the well-established process of woodcut. Wood-engraved blocks have their images standing in relief, which means that they can be printed along with type (fig. 37). The use of the term 'engraving' suggests a kinship with copper-engraving, which is mis-leading: all it should imply is that the process offered something of the refinement of copperplate work. This greater refinement was achieved by using a different wood and different tools from those used in woodcutting. An engraver's pointed burin replaced the knife and gouge as the principal tool, and boxwood cut across the trunk of a tree

37. One of many wood-engraving blocks that have survived from the firm of the Newcastle engraver Thomas Bewick. This particular block, used for his *British birds* (1797–1804), has a re-engraved circular plug to the left of the climbing boy, which was the way in which corrections to blocks were usually made. 42 × 76 × 23 mm.

replaced other woods cut along the plank. As it happens, there is evidence of the use of both boxwood and burins in what we call woodcutting well before the close of the eighteenth century. Bewick's contribution was simply to bring all these developments together and produce images that conveyed tone, texture, and naturalistic effects with sufficient precision to provide high-quality illustrations in books.

Bewick was self-trained as far as making relief prints goes, but his innovations met the needs of the times so well that they spread to many parts of Europe within decades. This was all the more remarkable because he worked for most of his life far away from London in Newcastle. He is best known for his natural history books, and particularly for his *British birds* (1797–1804), which has captured the hearts of those interested in the natural world through its images of birds and scenes of country life (fig. 38). His books and the apprentices he trained helped to make his techniques of wood-engraving known in London, Paris, Munich, and even in America before he died.

Bewick's innovation made it possible to print refined pictures alongside text without printing a sheet twice. What is more, boxwood is extremely tough and blocks made from it were able to withstand very long print runs: Bewick estimated that around one million prints had been taken from one of his blocks. In the 1820s wood-engravings found their way into periodicals on a regular basis, but it was the

38. Thomas Bewick, *British birds* (1797–1804). Bewick developed the process of wood-engraving to such a degree that refined images could be printed by the same means as the text. His technical mastery of the process and delightful imagery prepared the way for its use in countless illustrated books and journals in the nineteenth century. Page size 232 × 125 mm.

39. (OPPOSITE) Cross-section of the offices that produced *Harper's New Monthly Magazine,* New York, published by the magazine in 1865. By this time the magazine had published around 10,000 illustrations (in a period of around fifteen years) and had a print run of 125,000 copies. The drawing shows, working from the bottom floor upwards: (1) Steam engines, some printing machines, and paper being prepared; (2) The main press rooms; (3) Sheets being dried and pressed; (4) Folding and gathering sheets; (5) Sewing; (6) Binding; and (7) Compositors and the electrotyping of wood-engraving blocks. The wood-engravings were produced out of house. Image size 110 × 119 mm.

Penny Magazine (founded in 1832), the *Magasin pittoresque* (founded in 1833), and, most significantly, the *Illustrated London News* (founded in 1842), that ensured the success of the illustrated press in Europe and, later, in America (fig. 39). Within a few decades wood-engraving had been converted from a craft to an industrial trade. The demand for both illustrators and wood-engravers was enormous, not only for the journals of the period, but also for the vast numbers of trade catalogues required by manufacturers and retailers across Europe and on the east coast of America.

The consequence of all this was that the wood-engraving trade had to develop ways of dealing with the increasing demands put on them, and particularly the quick turn-around of jobs. Bewick engraved from his own drawings and those of his assistants, and the same assistants sometimes engraved from the master's drawings. But within a generation it became common practice for engravers to do nothing but translate the drawings of other artists.

From around 1860 a method of manufacturing wood blocks was developed which involved bolting parts of a block together in such a way that they could be separated for distribution within the workshop. The drawing was done on the whole block, which was divided up for engraving by different people. The parts were then bolted together again and any awkward joins disguised by further engraving (fig. 40). From then on illustrations for periodicals could be large and yet still meet the weekly deadline. Inevitably this method led to specialists who were good at engraving foliage, architecture, people, and so forth. The demand for illustrations was so great that some firms even began to develop specialisms. One of these was the wood-

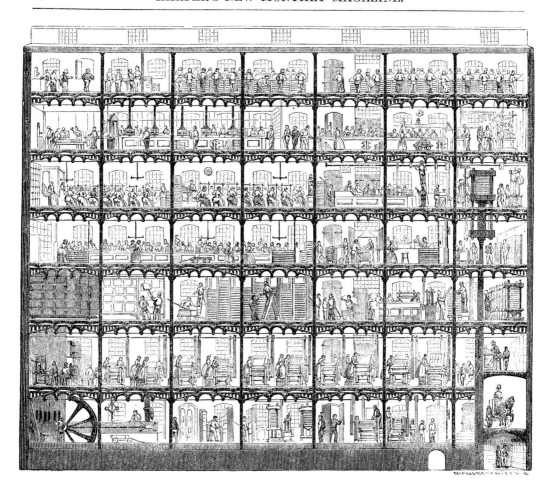

30 HARPER'S NEW MONTHLY MAGAZINE.

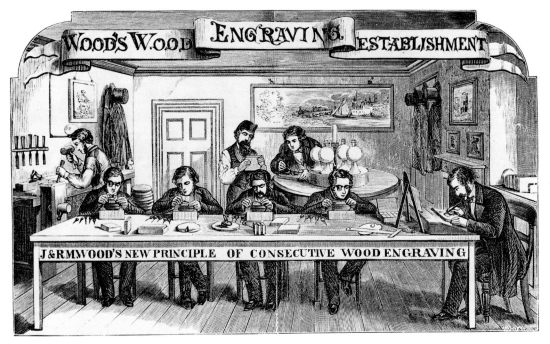

40. View of 'Wood's wood engraving establishment', published in the company's *Typographic advertiser* in 1863, showing an extreme form of division of labour in wood-engraving. Work started with the draughtsman on the right and passed to a succession of wood-engravers who undertook various kinds of work according to their skills, such as outlines, parallel shading, and removing backgrounds. The foreman, standing in the centre, engraved the most critical work, such as faces, and generally supervised production. The figure to his right is shown inking up a block for proofing. Image size 102 × 171 mm.

engraving of machines and other man-made products for manufacturers' catalogues, a branch of work which survived well into the twentieth century in some fields.

The illustrations that appeared by the millions in periodicals and catalogues all over the developed world in the nineteenth century are usually referred to as wood-engravings. Most of them were certainly engraved on wood, but many would have been printed from metal replicas, either stereotype or electrotype blocks. Stereotyping in one form or another goes back to at least the sixteenth century, and by the eighteenth century was being used for complete books. In its early days it involved taking a lead cast of a forme of type by means of a plaster or sand mould. From the early nineteenth century it became more common to use a *papier mâché* mould, which was produced by striking wet *papier mâché* against a forme of type with a hard-bristled brush. In this period stereotyping was widely used for the multiplication of formes of type for books that needed regular reprinting, such as school books.

Electrotyping was a more refined process and depended on the development of the electric battery. It involved dusting a wood block with graphite and depositing a thin film of copper on to it by electrolysis; the copper had then to be reinforced from behind with lead and

mounted on to a block. Stereotyping was the cheaper and more commonly used of the two methods, particularly for journals; electro-typing was usually reserved for higher class work. Making duplicates or multiple copies of blocks served two important functions: first, the original block could be preserved rather than put at risk on the press; secondly, the same image could be printed simultaneously on more than one press, thereby speeding up production. Making copies of blocks also opened up the possibility of an international trade in images for relief printing.

The search for verisimilitude

Though the printing of words continued to be practised in the nine-teenth century much as it had been for centuries, the methods used for printing pictures changed radically. The explanation for this difference is not hard to seek: words carry their meaning almost regardless of the form they take or the way they are printed, whereas the content of printed pictures is strongly influenced by the method used for their reproduction. For example, crude outline woodcuts can convey little of the texture of an animal's skin or the reflections on the surface of water. The growth of science, antiquarianism, and travel, together with changes in attitudes to art, all helped to stimulate a search for ways of printing pictorial images that looked more convin-cing than those of earlier days. The result of all this was a spate of new ways of originating printing surfaces. Ideally these new methods had to meet the above needs and also produce many copies cheaply, though for most of the nineteenth century these two requirements were not easily reconciled.

Two significant advances in this direction were made in intaglio printing. The first of these was the substitution of steel for copper, an idea that is credited to an American, Jacob Perkins (1766–1849). He used steel plates in his search for a method of producing unforgeable banknotes in the first decade of the century. Steel plates were tougher than copper ones and therefore gave longer print runs; they also made it possible to engrave very fine lines that could withstand printing (fig. 41). From the 1820s his process was widely used in fashionable draw-ing room annuals, books of travel, and guide books. The delicacy of such work far surpassed that of any other process of the period in terms of the number of lines that could be printed in a given space. For

41. Specimen of siderography (steel engraving) by Perkins, Fairman & Heath showing the possibilities of his process for banknote and other security printing. Perkins's process of steel engraving involved the repetition of elements of a design by impressing them several times on to a cylinder of soft steel, which was then hardened. In turn this cylinder was used to impress an image on to any number of soft steel plates or many times on to the same plate.

42. Detail of an intaglio-printed plate produced by the process called medal engraving or anaglyptography. It was used here to simulate the three-dimensions of the relief sculpture of the Parthenon frieze. Part of a complete reproduction of the frieze produced by Achille Collas for his *Trésor de numismatique et de glyptique* (Paris, 1835). 86 × 53 mm.

this reason, and because Perkins's process also made it possible to replicate images on the same plate to all intents and purposes identically, it was used for security printing. Perkins set up a company in Britain with others and one of his lasting claims to fame was that his firm printed the Penny Black postage stamps.

What are often called steel engravings were not engraved on steel, but etched on copper (usually with some engraving); the copper plates were then faced with a thin coating of steel by means of electrolysis. This technique was not developed until the 1840s and depended on the newly invented electric battery.

Some processes were more directly the result of a quest for verisimilitude. One of these was the process known as medal engraving or anaglyptography, which was used in the 1830s by Bates in London and Collas in Paris to reproduce three-dimensional surfaces (such as relief sculpture and medals). It involved plotting the relief of an object repeatedly with a tool with two arms set at right angles. One arm followed the contours of the object while the other left a trace of these movements on a coated intaglio plate. The repeated movements of the tool resembled the process of scanning and produced a passable imitation of a three-dimensional surface on paper (fig. 42). Another process that aimed at verisimilitude was nature printing, which was used by Alois Auer in Vienna and Henry Bradbury in London in the 1850s to produce facsimiles of plants. The essence of the idea goes back centuries, to taking impressions from actual leaves (which is a form of relief printing). But instead of printing from leaves or similar forms, Auer and Bradbury pressed them into soft pewter, thereby producing an intaglio (hollow) image. The pewter was too soft to give more than a few impressions, so a cast was taken in a harder metal for the printing of editions (fig. 43).

The most effective of these quests to capture life-like effects on paper was photography, which brought together ideas

43. Detail of Henry Bradbury's nature printing, from an intaglio-printed plate of 'Cystoclonium purpurascens' in W. G. Johnstone and A. Croall, *Nature-printed British sea-weeds* (London, 1859–60). 62 × 47 mm.

that had been around for centuries. The two strands of what we consider to be the invention of photography were made public by Daguerre in France and Fox Talbot in England in the same year, 1839. The link between photography and printing had been obvious from the start. The form of photography invented by Louis Daguerre (1787–1851) produced unique images on metal plates, and examples survive of his attempts to make multiple prints by etching such plates. The process announced by William Henry Fox Talbot (1800–77) involved the use of paper negatives, from which numerous prints could be taken; seen in one light, therefore, it could be regarded as a rather slow form of printing. But both branches of photography were handicapped to some degree because they lacked a method of multiplying their images quickly and in large numbers.

At the outset, the solution to this problem was for draughtsmen to copy photographic images on to printing surfaces so that they could be engraved or otherwise produced for printing. Clearly this approach did not accord with the purist notion of 'sun pictures', and by the middle of the century ambitious attempts were made in Paris by Lerebours, Lemercier, and Poitevin to print from photographic images on stone. Despite this ambitious start, multiplying the continuous tones of photographs by a printing process proved particularly difficult, and it took the best part of fifty years before photographic images were reproduced commercially across a wide range of products.

44. Photograph of an agricultural elevator exposed on to a wood-engraving block and partially engraved by the firm of Hare. Only the part of the image that was needed for reproduction was engraved, leaving the rest of the photographic image still visible. An electrotype copy of the engraved part would have been taken for printing. The block dates from the early years of the twentieth century. 193 × 180 × 23 mm.

An intermediate stage in this development was the discovery of a way of applying a light-sensitive coating to a wood-engraving block and exposing it to light through a negative, just as a photographic print might be produced on paper (fig. 44). All the wood-engraver then had to do was engrave through the tones on the block in a mechanical way. Images of this kind were first produced in 1858 and became common in magazines and trade catalogues throughout the rest of the nineteenth century.

The discovery of what eventually brought photography and printing

45. Two of a set of ten illustrations in the *Process engraver's compendium* (London, [1932]) showing different resolutions of half-tone screens for letterpress (relief) printing. The example on the left (45 dots an inch) was then held to be suitable for newspaper and similar work; that on the right (100 dots an inch) for printing on smoother paper. The letterpress industry standard for years was 133 dots an inch, though finer screens were available and sometimes used. Lithographic printing led to the use of even finer screens; the half-tone illustrations in the book you are reading were printed by lithography at 175 dots to the inch.

together was the half-tone screen (fig. 45). This was a means of breaking down a light source into dots of varying intensity, which were then interpreted as dots of different sizes or hollows of different depths according to the printing process used. The idea of using screens for this purpose was first mooted by Fox Talbot in 1852; it was taken up in many parts of the world and used most effectively by Frederick Ives in America. Ives is generally credited with having developed the first convincing photographic half-tone plates for letterpress printing in the early 1880s. Within a decade the idea had become a commercial reality in both America and Europe, and by the beginning of the twentieth century photographic illustrations were being used in books, journals, and newspapers on a regular basis.

Colour printing becomes a necessity

Colour printing did not disappear entirely in the period of monochrome print production. Books for the church were commonly printed in red and black, and several special techniques were developed to make this practicable. Printing text in colour was also occasionally done as a novelty (fig. 46). But coloured inks were troublesome to make and use, and in the case of pictorial prints it was usually cheaper and more effective to add colour by hand. An intermediate position was developed through what is called 'chiaroscuro' printing (after the Italian for light and dark), by which an image is printed in a range of tones of more or less the same hue by successive

46. L. A. Caraccioli, *Le livre de quatre couleurs* (2nd edn, Paris, 1760). This is one of the very few letterpress books that departs from the longstanding convention of printing text in black. Its text pages are printed in one of four different colours, including an almost illegible yellow, and all four colours appear on its title-page. Page size 173 × 110 mm.

workings. Woodcuts of this kind are to be found from the late fifteenth century onwards, and the idea was also applied to other printing methods.

Gradually the position changed. In the eighteenth century wall-paper, reproductions of paintings, and anatomical illustrations began to be printed in colour. The favoured techniques for such work were printing from wood blocks and mezzotint. The first of these was merely an extension of chiaroscuro printing, and involved using ink of different hues rather than tones on separate blocks. Mezzotint was much the more refined of the two processes and had the particular advantage that parts of the plate, even small features of a face, could be inked up separately in different colours (*à la poupée*) with stumps of soft leather or cloth. Mezzotint was also used for the earliest experiments in producing the effect of full-colour images from just three or four separately printed colours (fig. 47). But all these methods were relatively slow and expensive and therefore tended to be limited to special classes of work.

In the early nineteenth century it became imperative to find ways of producing coloured images relatively cheaply. The impetus for this came initially as much from science and scholarship as it did from aesthetic or even commercial considerations: books on natural history, archaeology, and travel called for reliable replication of colour, as did

many maps. But with the increase in the size of print runs, hand-colouring became untenable, and numerous attempts were made to replace it with printed colour. All the major printing processes were used for this purpose, sometimes in combination with one another.

The earliest successful attempts at colour printing in the nineteenth century were made by a letterpress printer in London, William Savage (fig. 48), who used as many as twenty-nine wood-block printings to produce one of the colour prints in his own book *Practical hints on decorative printing* (London, 1822). He turned out to be ahead of his time, and it was not until the mid 1830s that colour printing began to engage the minds of printers more widely. In this period C. J. Hullmandel, George Baxter, and Charles Knight in England, and Godefroy Engelmann in France all came up with practical solutions to the problem, and all except Baxter employed fewer workings than Savage. Hullmandel and Engelmann used lithography, Baxter a combination of intaglio and relief printing, and Knight relief printing on its own. The practical efforts of these men were to change the nature of printing pictures more radically than any single technical development of the period. Photography had managed to capture the appearance of the natural and man-made world as far as tone was concerned, but it was a long while before it could cope with colour.

Once pictures began to be printed in colour, letterpress printers took up the much easier task of printing words and decoration in colour. Some lottery and theatre bills had already been printed in colour (*see* fig. 9), but by the 1840s the streets of London were being enlivened by colour-printed posters for theatres, circuses, and other entertainments. In this period books too began to be printed in colour, many of them in response to the antiquarian revival of interest in richly coloured medieval books.

Two major difficulties had to be resolved for the colour printing of pictures to succeed: one had to do with visual judgement, the other with technicalities. The first was the more difficult of the two and nowadays beggars belief. It was the task of dividing up an existing, fully-coloured image into a series of separate workings, each representing a different colour. This may have been a relatively simple task when only six to eight different colours (workings) were held to be necessary to produce a passable reproduction of a picture. But some reproductions of paintings required around twenty workings, and a few recorded examples many more. The task of deciding which parts

47. (OPPOSITE AND RIGHT) Jacob
Christoph Le Blon (1667–1741), who
was born in Frankfurt, was the first
to create colour-printed images from
just three or four separate workings.
The process he used to do this was
mezzotint, but the same idea was
adopted by Godefroy Engelmann in
France for his process of chromolitho-
graphy (patented 1837), and also
underpinned most photomechanical
printing of the twentieth century.

(OPPOSITE) Le Blon's separations for a
mezzotint portrait of Cardinal de Fleury
showing workings in yellow, blue,
yellow and blue combined, and red.
Each image 145 × 110 mm.

(RIGHT) Le Blon's finished mezzotint
portrait of Cardinal de Fleury printed
in three colours: yellow, blue, and red.

48. A plate from William
Savage, *Practical hints on
decorative printing* (London,
1822), printed in relief from
wood blocks in ten colours
using his water-based inks.
In this particular image
Savage made no use of
engraved lines to produce
half-tones of the colours.
The resulting image has
many of the qualities of
some water-colour paint-
ings of the period. Image
128 × 205 mm.

of an image were to be drawn on which blocks or stones to achieve the desired effect demanded a high degree of visual intelligence and judgement.

The other difficulty was registration: that is, getting different colours on to the paper in exactly the right place when printing. This was even more of a problem in the nineteenth century than it is now as printing was nearly always done on damped paper. Paper stretches when damp and was yet another variable for the printer to cope with. Various devices were invented to help with registration. Early ones involved the use of registration marks in the margins of prints, which could be used to position successive sheets on a set of points. Later, when presses were mechanized, sheets were layed on the printing surface in precisely the same position with the help of grippers.

The process that took colour printing to peaks of technical achievement and also depths of vulgarity was chromolithography. This had its roots in the colour lithography of Barth in Breslau, Hullmandel in London, and Engelmann in Paris and Mulhouse, but was developed to such an extent that it outstripped all other colour printing processes commercially. It was given a tremendous boost in the 1880s with the invention by Benjamin Day in America of mechanical tints, consisting of lines, dots, and other patterns, that could be used by lithographic draughtsmen to get tonal effects quickly. Its other great advantage over competing processes was that the printing surface (whether stone or plate) was available in very large sizes. By the end of the nineteenth century lithographic stones were available in sizes up to 3ft by 5 ft (915 × 1525 mm). This meant that lithographers could make good use of one of the unique advantages of the process, which was the facility to transfer a printed image many times on to another stone (or plate). In the case of labels or cards, for example, it was possible to transfer the same image scores if not hundreds of times on to a stone (fig. 49). Each separate working of a chromolithograph had to be transferred to a stone, but this was usually well worth the effort because it multiplied the number of items that could be printed at one pass through the press and therefore increased output enormously.

Chromolithography provided late nineteenth-century society with virtually every kind of colour-printed artefact, from prestigious reproductions of medieval manuscripts through to throwaway scraps. It became the workhorse of colour printing until it was replaced by the three- and four-colour photomechanical processes. These methods

49. Half sheet of 59 chromolithographed images, printed in Germany for the American market around 1890. Considerable economies could be achieved at the multiplication stage of lithography by transferring the same image many times on to a large stone. This had to be done separately for each colour. The emphasis on economy is evident here from the way in which the images were made to fit into all the available space. It is likely that the double image shown in the detail would have been transferred 29 times, leaving a single image to be transferred on its own. Each image measures 80 × 55 mm. This sheet is referred to in its margins as a half sheet and measures 625 × 476 mm: the full sheet would therefore have been twice this size.

began to be applied to colour printing before the nineteenth century closed, and in the first few decades of the twentieth century made substantial inroads into the colour printing market, initially in relation to letterpress printing. Nevertheless, they took the best part of fifty years to oust chromolithography completely for certain kinds of work, such as brochures, show cards, and posters.

New types for advertising

An educated person of the eighteenth century would probably have found little difficulty reading a book set in type of the kind commonly used by scholars in fifteenth-century Italy. The design of types changed over the years, but only very slowly. And though the occasional complaint is known to have been made in the eighteenth and nineteenth centuries about modifications made to book types, these changes would hardly have been noticed by the average reader.

The same cannot be said of type faces designed in the nineteenth century for use in advertising (fig. 50). Before the close of the previous

50. This window bill, printed by John Soulby (junr) in Ulverston in the north of England in 1826, includes a range of the new display faces that had been introduced over the previous decade or so to draw attention to key words or phrases in advertising. 200 × 245 mm.

century all that most printers of advertising would have had at their disposal were the largest sizes of the kinds of types used for the text matter of books. This was soon to change. Advertising had to compete to be effective and the improvements made to presses and, later, the availability of cheaper paper in large sizes made this possible. In the course of the nineteenth century the largest posters produced by letterpress printers increased in size by a factor of at least six in linear measurement (perhaps forty times in terms of area). Inevitably, this created a need for larger and more eye-catching types.

Large types could not be cast in the traditional type mould of the kind Gutenberg is assumed to have invented. They could be cast from sand, which was already a common enough practice in the eighteenth century, or be made by striking a wooden master letter into a piece of molten metal and using this as a mould. Techniques of this kind were used to produce some poster types, but not the largest ones, some of which were over 2ft (600 mm) high. In addition to the expense involved, metal type locked up in a large forme would have been extremely heavy. Large poster types, and some smaller ones too, were therefore usually made individually from wood. Most would have been cut by specialist manufacturers, though in the early nineteenth century some were even cut in the printing house to meet an urgent need. It may not always be possible to establish whether wood or metal types were used on a particular bill or poster, though evidence of wood grain or slight differences between one letter and another may give the game away.

Cutting letters on wood by hand was slow and was gradually replaced by the use of mechanical routers, which were guided by templates. Routers allowed types to be produced more quickly than any craftsman could make them with gouges and knives, and also more or less identically. The mechanical router was an American invention and was widely used on both sides of the Atlantic from the middle of the nineteenth century. Its accuracy and regularity meant that some poster types could be produced in two or three parts, each of which could be inked up separately and printed in a different colour one after the other (fig. 51). Later, wood gave way to composition substances, and poster types were even made with a curved profile so that they could be fastened on to the cylinder of a rotary press.

The demand for wood poster types continued into the second half of the twentieth century, particularly for estate agents' posters and

51. W. H. Bonnewell & Co. 'Specimens of wood type', c. 1870. Two-colour wood poster types of this kind were commonly used on entertainment posters of the second half of the nineteenth century and into the twentieth century. Page size 505 × 310 mm.

advertisements for sporting events. A method of making type that was devised in the Far East was therefore still finding a commercial application more than one thousand years later in the West.

Speeding up production

The industrial revolution made its impact on printing at the very beginning of the nineteenth century, and by its close most of the operations of printing were mechanized to some degree.

A modest development was made with the manufacture of iron platen presses more or less along the lines of the common press. The first of these was the Stanhope press, which was introduced around 1800 (fig. 52). It incorporated a system of compound levers which meant that it became possible to print much larger areas at one pull of the press, and therefore increase output. The Stanhope press was followed by many other iron platen presses, the best known being the American Columbian and the British Albion.

Improvements of this kind may have been useful to book and jobbing printers, but were of no great consequence to newspaper proprietors, and it was the newspaper and periodical trades that forced

52. A Stanhope press illustrated in J. Johnson, *Typographia, or the printers' instructor* (London, 1824). This was the first of the iron presses and it introduced a system of compound levers which allowed a complete forme of type to be printed at one pull of the press. The version shown here, with curved sides (cheeks), was a modification of the earliest Stanhope design.

53. Drawing of one of Koenig's powered cylinder presses of 1814, which applied pressure to a flat forme of type by means of an impression cylinder. The entire process was mechanized, apart from the feeding of sheets, which was done by hand. No Koenig presses survive.

the pace. Their needs were met by a more momentous development: the application of steam power to printing. This was the contribution of Friedrich Koenig (1774–1833), a German engineer who was working in Britain at the time. In 1810 he tried applying steam power to a press which had a vertical pressure system. This does not appear to have been a success and over the next few years he turned his attention to adapting and mechanizing the pressure system that had been used for centuries on the rolling press of the copperplate printer. The result was the first power-driven cylinder press (fig. 53).

A Koenig cylinder machine was secretly installed at the offices of *The Times,* and the first issue of the paper to be printed on it came out on 29 November 1814. The press had a moving bed on which a flat forme of type travelled successively under inking rollers and an impression cylinder. This was a principle that was adopted for countless letterpress machines through to the second half of the twentieth century. Koenig's machine enabled printing to be done four or five times as quickly as on a hand press, and before long he had made improvements that doubled the previous output by printing on both sides of the paper at one pass through the press.

A factor that severely limited the output of powered printing machines was the hand feeding of sheets of paper. A short-term solution was to increase the number of feeding stations on a machine, and newspaper presses were built in America and Britain with as many as eight or ten feeding stations and a similar number of stations

70

for removing the printed sheets. By the middle of the century gigantic machines of this kind, with their type fixed to a large polygon, were capable of printing over 10,000 impressions an hour (fig. 54). The inventors of such presses, ingenious though they were, failed to grasp the obvious: that the best way of feeding paper into a powered machine was from a reel. In this form it could be fed continuously between an impression cylinder and a cylindrical printing surface with little human intervention.

This idea depended on finding an effective way of converting a flat forme of type into a cylindrical shape, and the solution to this problem lay with an existing idea, the *papier mâché* method of stereotyping. *Papier mâché* moulds could be made from flat formes of type and then curved so that metal casts could be made from them and fitted around the cylinder of a press. The perfection of this process made possible the first rotary printing machines of William Bullock of Philadelphia and John Walter III of *The Times*, which were used in the 1860s to print 10,000 copies of complete newspapers in an hour.

More significantly, these men developed the idea of feeding their machines directly from reels of paper, an idea which has subsequently

54. The Applegath vertical rotary machine shown here, which was in use in Britain in 1848, and the American Hoe ten-feeder, took the issue of feeding paper by hand as far as it could reasonably go. In the Applegath press, type was mounted on to a vast vertical polygon and sheets the size of two pages of a newspaper were fed by hand from eight stations and taken off by a further eight people.

been adopted for most high-speed presses, whether relief, intaglio, or planographic. There is some irony in the fact that paper-making machines – which were invented at the close of the eighteenth century in France and were taken up quickly thereafter – manufactured paper in rolls, which were then cut up into separate sheets for the convenience of printers.

The relief branch of printing was the first to be mechanized, with newspaper production making the running. Gradually, however, powered machines worked their way down to less demanding branches of the trade, such as book and jobbing printing. And in turn these developments forced the lithographic trade to respond. After several unfruitful attempts in France in the 1840s, a successful powered lithographic machine was developed by an Austrian engineer, Georg Sigl, in 1851. Sigl's machine printed from flat stones and incorporated automatic damping and inking (fig. 55). Powered lithographic machines of this and other kinds were taken up by leading lithographic firms from the 1850s, and speeds of up to 1000 sheets an hour were claimed for them. Intaglio printing was even slower to be mechanized than lithography, and the demand for mechanization came principally from the need for vast quantities of postage stamps in the second half of the nineteenth century.

Speeding up the origination of type matter proved to be much more of a challenge than developing faster printing machines. The

55. Numerous experiments were made to mechanize lithographic printing in the wake of the use of powered machines for letterpress printing (1814). The first successful lithographic machine, patented in 1851, was that of the Austrian engineer Sigl. It had automatic inking and damping and could be worked by steam or by hand. The hand-powered version shown here was illustrated in the *Journal für Buchdruckerkunst,* 1852.

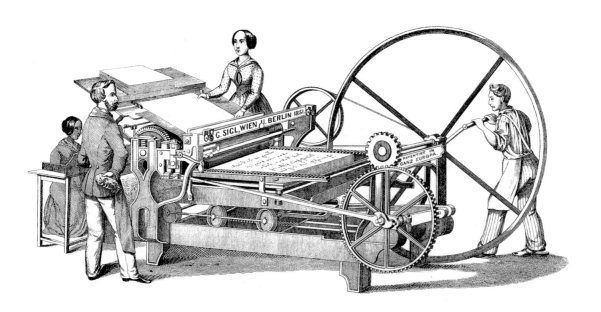

problem can be considered in two parts: casting type more quickly and speeding up its composition. The process of casting type lent itself to mechanization more easily than did composition and its production was speeded up dramatically in the middle of the nineteenth century. The first effective typecasting machine was invented by David Bruce of New York in 1838 and was capable of producing type at least ten times as quickly as someone casting type by hand. A further significant improvement was made with the Wicks rotary caster, patented in 1881, which had an output ten times faster still.

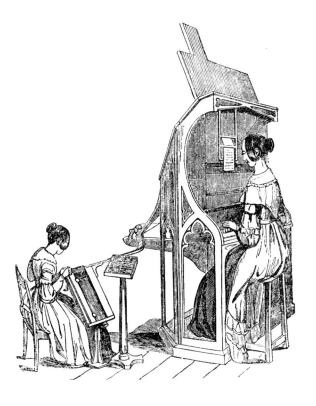

Speeding up the composition of text matter proved to be a particularly intractable problem and exercised the minds of countless nineteenth-century engineers. The first set of ideas turned on bringing together pre-cast type by using a keyboard which governed the release of characters one by one. Machines of this kind were made around 1840, though the idea had been patented as early as 1822. One such machine, the 'Pianotyp', which was illustrated at the time being operated by women (fig. 56), was used for several publications in 1842. It was followed by a raft of similar machines which were used primarily for newspaper composition from the 1860s. All these machines were handicapped by not having a mechanical means of spacing type along the line after it had been set. All the same, they went some way to solving the problem of mechanizing text composition and a few of them continued in use for around half a century.

In retrospect we can see that the designers of all these machines were barking up the wrong tree by searching for quicker ways of organizing existing type. Machines that were designed on entirely different principles dominated the printing industry for the first two-thirds of the twentieth century. These machines combined the operations of casting and setting, and cast their type from matrices

56. The first working machine for composing type was the 'Pianotyp' of Young and Delcambre, which was patented in England in 1840 and used for several years. It was operated by two people. One worked a keyboard, which released characters in the correct sequence into a setting stick. The other introduced spacing between words and justified the line, much as a traditional compositor would have done. The use of women to promote the machine was seen as a threat to the male dominated printing trade.

57. The Linotype room of the offices of the *Sheffield Daily Telegraph* around 1901 when it had more than twenty machines. The Linotype machine cast each line of type in sequence in the form of a single piece of metal (slug). It was rapidly taken up by the newspaper industry where it dominated the field for around seventy years in Europe and America. It was also widely used for book work in America, but less so in Britain.

58. Monotype keyboard room at Oxford University Press around 1926 showing about twenty keyboards in use. Perforated paper spools produced on these keyboards controlled the setting of the type; these spools were then passed to the caster room where they instructed machines to cast type letter by letter in the correct sequence to form lines and pages.

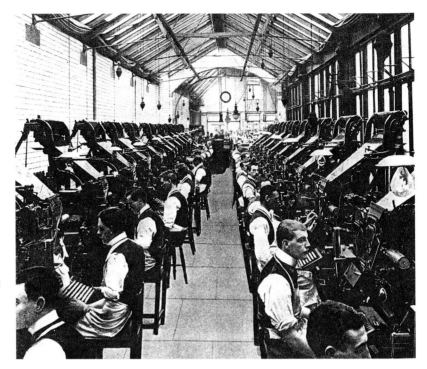

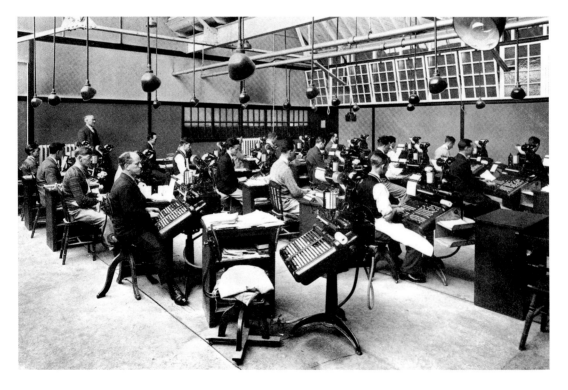

only after the sequence of characters along the line had been determined following instructions from a keyboard.

Two machines led the field: the Linotype and the Monotype. The first was designed by a German mechanic, Ottmar Mergenthaler (1845–99), who had recently emigrated to America. It worked by assembling and spacing rows of individual matrices and taking casts of complete lines from them (hence the name). The first Linotype machines were built in 1886, though a succession of improved versions soon followed (fig. 57). The Monotype machine was developed by Tolbert Lanston (1844–1913) of Washington; it was put on the market in America in 1894 and three years later was being sold in Britain. It consisted of two units, a keyboard which provided perforated tape and determined the sequence of characters along the line, and a caster which was controlled by the tape and composed text consisting of individual pieces of type (fig. 58). Both the Linotype and Monotype machines were highly successful and within a couple of decades had made real inroads into the work of the hand compositor.

The story of the mechanization of printing shows one very clear pattern: a shift in innovation from Europe to America. At the beginning of the nineteenth century most of the significant developments came from Europe; increasingly, and certainly from the middle of the century, America led the way.

From analogue to digital

Letterpress gives way to lithography

Over the first few decades of the twentieth century the printing industry settled into a pattern of mechanized production. This involved the use of hot-metal typesetting machines and the reproduction of pictures by photomechanical means. Many large firms followed this pattern, though smaller ones – probably the majority in terms of companies – continued to use at least some of the technology of the nineteenth century. Relief printing still dominated the scene, though lithographic printing was rapidly catching it up where pictures or decorative work predominated (fig. 59). In this period too, colour printing that made use of photography to separate fully-coloured images into three or four component colours became common, initially in relation to relief printing.

The most significant development across a broad front in the first half of the twentieth century was the growing use of photography in print production. Photography had already been used to make pictorial blocks for relief printing before the close of the nineteenth century; this practice continued, but in lithographic and intaglio printing photographic methods began to be applied to whole publications. It took time for this development to make itself felt, and in some fields it was much slower than in others. For example, some large-circulation illustrated magazines had their pictures and text printed by photogravure from the close of the First World War (fig. 60), whereas illustrated books were not commonly produced by photolithography until after the Second World War. In general, however, printing in technically advanced countries involved a steady increase in the use of

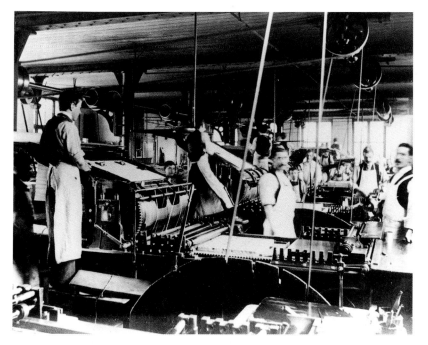

59. View of a the lithographic machine room of Charles Goodall & Son, London, around 1900. The firm specialized in the printing of playing cards. The machines are shown printing from stone, which was still in common use industrially in this period.

60. This double spread from the first number of the early cinema magazine *Cinémonde* (Paris, 1928) shows how photographic illustrations could be integrated with text in innovatory ways using the intaglio process of photogravure. Page size 360 × 260 mm.

photography at the origination stage. This had the gradual effect of restricting relief printing to particular categories of work, since it did not lend itself so easily as the other processes did to photographic methods.

At the beginning of the twentieth century lithographic printing took a significant step forward with the invention of offset lithography. This process was used in Britain from the late 1870s for printing on tin (fig. 61), but was developed quite independently in America by Ira Rubel around 1903 for printing on paper. It involved transferring images to a rubber or composition cylinder, and from there to paper. The flexibility of the rubber cylinder meant that high-resolution illustrations could be printed on a wide range of papers. But even more important than this, such presses were of the rotary kind, which meant that lithography became competitive with letterpress at the machining stage when fast printing was required.

Printing machines increased in capacity and performance in the twentieth century, though they mainly followed the principles of earlier models. In the second half of the century, and particularly after the development of photocomposition, lithographic printing began to replace letterpress printing in most of its strongholds, with photogravure being restricted to large-circulation work such as magazines and stamps. By the end of the twentieth century most recently manufactured presses were controlled by computers to some degree.

61. Huntley & Palmers biscuit tins printed in colour by offset lithography by Huntley, Boorne & Stevens Ltd in Reading, UK, in the 1890s featuring Henley Regatta and the newly built Tower Bridge. Offset lithography was pioneered for printing on tin in Britain from the late 1870s and was developed independently for printing on paper in America about twenty-five years later. Its principal advantage for printing on tin plate was that the offset blanket provided a soft and resilient point of contact with the metal, which no other printing process could offer. 135 × 135 × 92 mm and 95 × 153 × 48 mm.

Some decades before this, letterpress printing of the kind used for the previous five hundred years had been shunted to the industrial sidelines; its fate was sealed in Britain with the change in newspaper production from letterpress to lithography in the 1960s and 1970s. The transition from letterpress to lithography in the printing industry as a whole may have taken the best part of one hundred years but, when it came, the end of commercial letterpress printing was comparatively quick.

Photocomposition

For the first fifty years of the twentieth century nearly all typesetting continued to be done on improved versions of the machines invented in the late nineteenth century, the Linotype and Monotype. These machines, admirable though they were in many respects, were invented with letterpress printing in mind. When used in connection with lithographic printing, high quality proofs had to be taken from type and then photographed to make lithographic plates. This was a sufficiently awkward procedure to prevent lithography from making substantial inroads into work in which text predominated.

The idea of making photographic images of letters even predates what we choose to accept as the invention of photography, as Josiah Wedgwood made photographic experiments with letters in the late eighteenth century. Fox Talbot followed suit in the mid nineteenth century (fig. 62). More significantly, in the 1890s, even before hot-metal composing machines had made much headway, W. Friese-Greene, of cinematographic fame, and E. Porzolt were both granted patents for the photographic composition of type. In the period between the two world wars a workable photosetting machine, the Uhertype, was marketed in Germany, but it was not until the Intertype Fotosetter was installed in Washington in 1946 that photo-composition really made its mark. Between then and the 1980s

62. William Henry Fox Talbot referred to 'A kind of photographic printing' as part of the improvements to photography he patented on 1 June 1843. He made a calotype negative (as shown here) from pre-printed letters that had been arranged individually in rows. A positive print was then made in whatever size was needed.

numerous machines were developed on a variety of principles that transformed the printing industry: some early ones used photographic negatives for the letters (fig. 63), later ones generated letters on a cathode ray tube. The significance of photocomposition was that it brought the origination of words and pictures together in a form that was convenient for lithographic printing (and to a lesser extent photogravure). It therefore affected the whole printing trade, not just the composition of text. But important though photocomposition was seen to be at the time, it represents only a brief interlude in the history of printing as a whole.

The use of typewriters in printed work had a very much longer history than photocomposition and dates from the late nineteenth century in America. In the mid twentieth century it was given a tremendous boost with the manufacture of electrically-driven machines using one-off carbon ribbons, which gave tolerable impressions of printing type using an assortment of type heads with

63. Matrix disc for a Photon Lumitye 540 filmsetter of the 1960s. The negative characters on this rotatable glass disc were exposed ten per second on to film in a sequence determined by tape from a keyboard. Such discs contained a mixture of fonts of type, each of ninety characters, which could be produced in sizes ranging from 5 to 72 point. Diameter 203 mm.

64. In the 1960s advanced electric typewriters with carbon-coated ribbons simulated traditional printing by offering users different sizes and styles of type. This was done by means of detachable elements that carried the shapes of the letters. Shown here are two golf-ball heads for the IBM 72 Composer (one for 10 point Univers medium roman, the other for its italic).

different sizes and styles of type (fig. 64). Machines of this kind, which became very popular in the 1960s, led to a substantial increase in office printing using small offset lithographic machines.

The digital revolution

The demise of photocomposition was even faster than that of hot-metal composition, and during the 1980s and first half of the 1990s it was almost entirely replaced in technologically advanced countries by digital methods. These decades saw the convergence of computing and printing, at least at the origination stage. Specialist software was developed for personal computers which generated the shapes of letters and helped to organize them on the page (fig. 65). The normal method of inputting text still remains a keyboard similar in arrangement to that used for well over a century by typists, though it is also

65. Pages 76–77 of this book shown as they appear on the screen to its designer, Andrew Shoolbred. The book was designed using an Apple Macintosh computer, QuarkXpress software for the text, and Photoshop for the pictures. The type, pictures, and organization of the pages are controlled by this software and, at the deepest level of the system, by binary instructions that control microchips in the computer.

possible to scan in existing typed or printed material, and in certain circumstances even handwriting. Experiments have been made with voice input of text too. Once it is composed, text can be organized with the help of software to produce pages in full typographic dress and – in skilled hands – with even more subtlety than hitherto. Pictures can be scanned into a computer for use alongside words, since all graphic marks in computing are generated by digital signals. These developments have undermined the specialist roles of the compositor, editor, and designer, and have made it possible for people from many walks of life to originate documents that look authoritative.

Multiple copies of such electronically produced documents can be obtained by means of laser printers, which deposit toner on the basis of instructions from the computer and fix it by a heat process. At present, the output of such laser printers is slow, but industrial machines have been manufactured that are considerably faster than office machines; in the context of printing they are unusual in that they are able to make each impression individual in some respect, for example by changing a name. But when large numbers of the same electronically originated documents are needed they are normally transferred photographically or directly to printing plates so that they can be multiplied quickly and to a high standard by lithographic methods.

The consquences of the electronic revolution in printing are significant, and possibly even more so than Gutenberg's invention of movable type. Most obviously, printing (using the word in the sense of multiplying documents) is now just one of several means of delivering the same electronically stored messages. Though the cultural impact of printing may have been diminished as a result of this diversifica-tion, there is no evidence whatsoever that society is using less printing than it did in the past. This suggests that the tangibility and portability of printed matter are characteristics that we have come to value highly.

Further reading

General (including the book)

Bland, David, *A history of book illustration* (London: Faber & Faber, 1958)

Bühler, Curt F., *The fifteenth-century book* (Philadelphia: University of Pennsylvania Press, 1960)

Chappell, Warren, *A short history of the printed word* (New York: Dorset Press, 1989)

Febvre, Lucian, and Henri-Jean Martin, *The coming of the book: the impact of printing 1450–1800* (London: Verso Books, 1986). First published as *L'Apparition du livre*, 1958

Gaskell, Philip, *A new introduction to bibliography* (Oxford, 1972; re-issued New Castle, DE, and Winchester, Hampshire, 1996)

Glaister, Geoffrey Ashall, *Encyclopedia of the book,* 2nd edn with a new revised introduction by D. Farren [a revised edn of *Glossary of the book,* 1979] (London and New Castle, DE, 1996)

Goldschmidt, Ernst P., *The printed book of the Renaissance: three lectures on type, illustration, ornament* (Cambridge: Cambridge University Press, 1950; reprinted with corrections, Amsterdam, Gérard Th. van Heusden, 1966)

Journal of the Printing Historical Society, no. 1, 1965 –

McLean, Ruari, *Victorian book design and colour printing* (London: Faber & Faber, 1963; 2nd edn enlarged and revised, 1972)

McMurtrie, Douglas C., *The book: the story of printing & bookmaking* (3rd edn, New York: Oxford University Press, 1943; reprinted London: Bracken Books, 1989)

Printing and the mind of Man: catalogue of a display of printing mechanisms and printed materials arranged to illustrate the history of Western civilization and the means of the multiplication of literary texts since the xv century (London, 1963)

Printing patents: abridgements of patent specifications relating to printing 1617–1857. First published in 1859 and reprinted with a prefatory note by James Harrison (London: Printing Historical Society, 1969)

Steinberg, S. H., *Five hundred years of printing,* (new edn revised by John Trevitt, London: British Library; New Castle, DE, 1996)

The Times, *Printing in the twentieth century: a survey,* reprinted from the Special Number of *The Times,* 29 October 1929 (London: The Times, 1930)

Twyman, Michael, *Printing 1770–1970: an illustrated history of its development and uses in England* (London: Eyre & Spottiswoode, 1970; reprinted London: British Library, 1998)

The invention

Carter, T. F., *The invention of printing in China and its spread westwards* (New York: Columbia University Press, 1925; revised by L. C. Goodrich, New York, 1955)

Ing, Janet, *Johann Gutenberg and his Bible* (New York: The Typophiles, and London: British Library, 1988; revised edn, 1990)

Scholderer, Victor, *Johann Gutenberg: the inventor of printing* (London: British Museum, 1963; 2nd edn 1970)

Tsien, T. H., 'Paper and Printing', in Joseph Needham (ed.), *Science and civilization in China* (Cambridge: Cambridge University Press, 1985), vol. 5, part I

Type design and manufacture

Carter, Harry, *An early view of typography up to about 1600* (Oxford: Clarendon Press, 1969)

Carter, Sebastian, *Twentieth century type designers* (2nd edn London: Lund Humphries, 1995)

Gray, Nicolete, *Nineteenth-century ornamented typefaces* (2nd edn, London: Faber & Faber, 1976)

Karow, Peter, *Digital formats for typefaces* (Hamburg: URW Verlag, 1987)

Lawson, Alexander, *Anatomy of a typeface* (Boston: David R. Godine, 1990)

McLean, Ruari, (ed.), *Typographers on type* (London: Lund Humphries, 1995)

Smeijers, Fred, *Counterpunch: making type in the sixteenth century, designing typefaces now* (London: Hyphen Press, 1996)

Updike, Daniel Berkeley, *Printing types: their history, forms, and use* (3rd edn Cambridge, Mass.: Harvard University Press; London: Oxford University Press, 1962)

Tracy, Walter, *Letters of credit: a view of type design* (London: Gordon Fraser, 1986)

Equipment and materials

Bloy, Colin, *A history of printing ink, balls and rollers* (London: Wynkyn de Worde Society, 1967)

Hills, Richard, *Papermaking in Britain 1488–1988* (London: Athlone Press, 1988)

Huss, Richard E., *The development of printers' mechanical typesetting methods 1822–1925* (Charlottesville: University of Virginia, 1973)

McIntosh, Alastair, *Typewriter composition and standardization in information printing* (Old Woking: Unwin Brothers, 1965)

Moran, James, *Printing presses: history and development from the fifteenth century to modern times* (London: Faber & Faber, 1973)

Peacock, John, *Book production* (2nd edn, London: Blueprint, 1995)

Richards, George Tilghman, *The history and development of typewriters* (2nd edn, London: HMSO, 1964)

Ringwalt, J. Luther (ed.), *American encyclopedia of printing* (Philadelphia, 1871)

Romano, Frank J., *Machine writing and typesetting* (Salem, NH, 1986)

Silver, Rolo, *Typefounding in America 1787–1825* (Charlottesville, 1965)

Wallis, Lawrence, *Typomania: selected essays on typesetting and related subjects* (Upton-upon-Severn: Severnside Printers, 1993)

Processes

Coe, Brian, and Mark Hayworth-Booth, *A guide to early photographic processes* (London: Hurtwood Press in association with the Victoria & Albert Museum, 1983)

Dyson, Anthony, *Pictures to print: the nineteenth-century engraving trade* (London: Farrand Press, 1984)

Gascoigne, Bamber, *How to identify prints* (London: Thames & Hudson, 1986; reprinted 1995)

—— *Milestones in colour printing 1457–1859* (Cambridge: Cambridge University Press, 1997)

Griffiths, Anthony, *Prints and printmaking: an introduction to the history and techniques* (2nd edn, London: British Museum Press, 1996)

Hind, Arthur M., *An introduction to a history of woodcut*, 2 vols (London: Constable & Co., 1935; reprinted New York: Dover Publications, 1963)

Hunnisett, B., *Steel-engraved book illustration in England* (London: Scolar Press, 1980)

Hunter, Dard, *Papermaking: the history and technique of an ancient craft* (2nd edn, London, 1947)

Lilien, Otto M., *History of industrial gravure printing up to 1920* (London: Lund Humphries, 1972)

Marzio, Peter C., *The democratic art. Pictures for a 19th-century America* (Boston: David R. Godine, 1979)

Peters, Harry T., *America on stone* (New York: Doubleday, Doran & Co., 1931)

Twyman, Michael, *Lithography 1800–1850* (London: Oxford University Press, 1970)

Wakeman, Geoffrey, *Victorian book illustration: the technical revolution* (Newton Abbot: David & Charles, 1973)

Weber, Wilhelm, *A history of lithography* (London: Thames & Hudson, 1966)

Non-book material

Davis, Alec, *Package and print: the development of container and label design* (London: Faber and Faber, 1967)

Gamble, William, *Music engraving and printing: historical and technical treatise* (London: Pitman, 1923; reprinted New York: Arno Press, 1979)

Hutt, Allen, *Newspaper design* (London: Oxford University Press, 1960)

Ivins, William M. Jr., *Prints and visual communication* (Cambridge, Mass.: Harvard University Press, 1953; reprinted M.I.T. Press, 1982)

King, A. Hyatt, *Four hundred years of music printing* (London: British Museum, 1964)

Krummel, Donald W., and Stanley Sadie (eds), *Music printing and publishing* (Basingstoke & London: Macmillan, 1990)

Lewis, John, *Printed ephemera: the changing uses of type and letterforms in English and American printing*

(Ipswich: W. S. Cowell, 1962)

Mackenzie, A. D., *The Bank of England note: a history of its printing* (Cambridge: Cambridge University Press, 1953)

Melville, Frederick James, *Postage stamps in the making* (London, 1916)

Rickards, Maurice, *The public notice* (Newton Abbot: David & Charles, 1973)

—— *Collecting printed ephemera* (Oxford: Phaidon–Christie's, 1988)

Skelton, R. A., *Decorative printed maps of the 15th to 18th centuries* (London & New York: Staples Press, 1952)

Twyman, Michael, *Early lithographed music* (London: Farrand Press, 1996)

Woodward, David (ed.), *Four centuries of map printing* (Chicago & London: University of Chicago Press, 1975)

Practical manuals on printing

Bosse, Abraham, *Traicté des manières de graver en taille douce sur l'airin* (Paris, 1645)

De Vinne, Theodore Low, *The practice of typography: correct composition* (New York, 1901; and later edns)

—— *The practice of typography: modern methods of book composition* (New York, 1904; and later edns)

—— *The practice of typography: a treatise on the processes of type-making, the point system, the names, sizes, styles and prices of plain printing types* (New York, 1900; and later edns)

Fielding, Theodore Henry, *The art of engraving, with the various modes of operation* (London, 1841; 2nd edn 1844)

Fournier, Pierre-Simon, *The* Manuel typographique *of Pierre-Simon Fournier le Jeune, together with* Fournier on Typefounding, *an English translation of the text by Harry Carter* {1764, 1766, 1930]. Facsimile, with an introduction and notes by James Mosley, 3 vols (Darmstadt, 1995)

Hackleman, Charles W., *Commercial engraving and printing. A manual of practical instruction and reference covering commercial illustrating and printing by all the processes* (Indianapolis, 1921; 2nd edn 1924)

Hansard, Thomas C., *Typographia: an historical sketch of the origin and progress of the art of printing; with practical directions for conducting every department in an office* (London, 1825; reprinted London: Gregg Press, 1966)

Hullmandel, Charles Joseph, *The art of drawing on stone* (London, 1824; 2nd edn 1833; 3rd edn 1835)

Jackson, John [with Chatto, W. A.], *A treatise on wood-engraving, historical and practical* (London, 1839; 2nd revised edn 1861)

Le Blon, Jacob Christoph, *Coloritto or the harmony of colouring in painting: reduced to mechanical practice* (London, 1725; reprinted in Otto M. Lilien, *Jacob Christoph Le Blon,* Stuttgart: Anton Hiersemann, 1985, pp. 178– [225])

Legros, L. A., and Grant, J. C., *Typographical printing-surfaces: the technology and mechanism of their production* (London, 1916)

Linton, W. J., *Wood-engraving: a manual of instruction* (London, 1884)

Moxon, Joseph, *Mechanick exercises on the whole art of printing* (London, 1683; edited by Herbert Davis and Harry Carter, London: Oxford University Press, 1962)

Papillon, Jean-Michel, *Traité historique et pratique de la gravure en bois,* 2 vols (Paris, 1766)

Phillips, Arthur H., *Computer peripherals and typesetting* (London: HMSO, 1968)

Raucourt de Charleville, Antoine, *A manual of lithography,* translated by C. Hullmandel (London, 1820; 2nd edn 1821)

Richmond, W. D., *The grammar of lithography. A practical guide for the artist and printer* (London, 1878; many later edns)

Savage, William, *Practical hints on decorative printing* (London, 1822)

Senefelder, Johann Aloysius [Alois], *Vollständiges Lehrbuch der Steindruckerey* (2 vols, Munich and Vienna, 1818; 2nd edn 1821; 3rd edn 1827). Translation of 1821 edn by J. W. Muller published as *The invention of lithography* (New York, 1911)

Seybold, John W., *Fundamentals of modern composition* (Media, Pennsylvania: Seybold Publications Inc., 1977)

Southward, John, *Modern printing: a handbook of the principles and practice of typography and the auxiliary arts,* 4 vols, (London, 1898–1900; several later edns)

—— *Practical printing: a handbook of the art of typography* (London 1882; several later edns)

Wilkinson, W. T., *Photo-engraving, photo-litho, collotype and photogravure* (London, 1892; several later edns)

Index